IMAGES
of America

SOUTHERN ARIZONA MINING

These miners pose with the 3.5-ton chunk of azurite, malachite, iron, and manganese oxide copper ore that was extracted from Bisbee's Czar mine in 1891. It was sent to the World's Columbian Exposition in Chicago in 1893 for the Arizona exhibit. After the exposition, sections were removed, with one still on display at the gem and mineral hall of the American Museum of Natural History in New York City. (Photographer unknown. Collection of the author © vintagephoto.com.)

ON THE COVER: This classic 1900 photograph shows an unidentified miner posing with his mule as it pulled a heavily loaded ore cart from a mine near Clifton, Arizona Territory. Note the leather camera case the photographer left on the ground in the lower right side of the image. (Detail of silver print, photographer unknown, c. 1900. Collection of the author © vintagephoto.com.)

IMAGES
of America

SOUTHERN ARIZONA MINING

Jeremy Rowe

ARCADIA
PUBLISHING

Published by Arcadia Publishing
Charleston, South Carolina

Printed in the United States of America

Library of Congress Control Number: 2022949705

For all general information, please contact Arcadia Publishing:
Telephone 843-853-2070
Fax 843-853-0044
E-mail sales@arcadiapublishing.com
For customer service and orders:
Toll-Free 1-888-313-2665

Visit us on the Internet at www.arcadiapublishing.com

Our understanding and appreciation of Arizona's history are made possible by the photographers that braved toxic chemistry, heavy equipment, glass-plate negatives, and primitive, often dangerous, travel and working conditions to create their images. This book is dedicated to these pioneers, be they amateurs or professionals that took the time to capture these images for posterity; and to my wife, Doreen; my daughter, Alyssa; her husband, J.B. North; my grandsons, Brendan and Ethan Bradford and Devin North; and my granddaughter, Sadie May North, in hopes that they will help continue to preserve and interpret this visual legacy.

CONTENTS

ACKNOWLEDGMENTS

I would like to thank my fellow collectors and dealers that have provided the images in my collection over the past 30 years. Also, my thanks go to the libraries, archives, museums and historical societies, and the network of fellow researchers and collectors that have helped unearth the background information that helps us understand and interpret these images. These interactions have been a passion and pleasure that will hopefully continue. Special thanks to organizations like the Daguerreian Society, the Ephemera Society of America, and the National Stereoscopic Association that have helped link collectors and researchers to share information.

I would also like to thank my editor, Caroline (Anderson) Vickerson, and the staff at Arcadia Publishing for their guidance and assistance in preparing this book.

INTRODUCTION

Arizona's climate, environment, and mineral wealth drew interest in the region from prehistoric times. Native Americans sought and found turquoise, obsidian, coal, quartz, and other resources. Stories of silver and gold drew Coronado and Spanish explorers, conquistadors, and priests to Arizona. Fray Marcos de Niza and Estévan de Dorantes came to Southern Arizona in about 1540 in search of the fabled Seven Cities of Cibola. Don Francisco Vásquez de Coronado followed a few years later. Explorers associated with his expedition visited the Hopi dwellings and Grand Canyon.

Despite several Indian uprisings, the Spanish established a presence in Southern Arizona. Their influence continued into the 18th and early 19th century as missions were established at Tumacácori (1691), San Xavier del Bac (1692), and Tubac (1752).

Spanish explorers prospected in the mountains near Sonoita Creek and the Santa Cruz River and found rich deposits of silver. A huge bola, or natural mass of silver, rumored to be close to 2,700 pounds found in the Planches de Plata District created a flurry of activity in the region. Silver from mines in the Santa Rita Mountains was used to decorate the altar at the San Xavier Mission south of Tucson. Despite repeated attacks by the Apache, Spanish settlers continued to work mines in the region into the 1830s.

During the Mexican War, the 60-foot shaft and remnants of the old Spanish mine north of Sonoyta at Ajo were visited by Tom Childs and a group of miners. After the Mexican War ended in 1848, Arizona, as part of the New Mexico Territory, transitioned from Mexican to American rule. After the war, though on the southern route to California, Arizona found itself overshadowed by the gold rush triggered by the discovery at Sutter's Mill. Though an estimated 60,000 people crossed Arizona en route to California, their focus was on the goldfields, and few of the travelers had a little lasting impact on mining in Arizona.

In 1851, along the Gila River east of Yuma and near the western edge of today's Maricopa County, the Oatman family wagon train en route from Missouri to California was attacked, and young daughters Olive and Mary Ann were abducted by Apaches. Soon, the tale of the Oatman girls captivated the country. Mary Ann died of starvation in 1855, but eventually, Olive's ransom and rescue on February 28, 1856, by a party led by her brother Lorenzo and the stories of her ordeal with the Apache and Mohave made headlines, generated books, and introduced Arizona to readers worldwide.

The Gadsden Purchase in 1854 brought the old mines in Southern Arizona into the United States. Members of Col. Andrew Gray's survey party seeking a southern rail route from Texas to San Diego visited the old mines at Ajo and took ore samples, eventually to San Francisco, where Peter Brady established the Arizona Mining and Trading Company with shareholders (several of whom began long and important relationships with mining in Arizona) including Robert Allen, Tom Childs, Colonel Gray, Granville Oury, and Frederick Ronstadt.

The US-Mexico border survey was completed in September 1855, and the old Spanish mines at Ajo were about 40 miles north of the new border. The remote, arid environment was challenging, but by the end of the year, claims had been filed and mining started in Ajo. Attempts at local

processing were unsuccessful, so the rich ore was carried by wagon via Fort Yuma to San Diego, where it was shipped to a copper smelter in Swansea, Wales. A shipwreck causing the loss of an ore shipment led to the mine closing in 1859.

In March 1856, another pioneer Arizona figure, Col. Charles D. Poston, German miner Frederick Brunckow, and a group of frontiersmen were sent to the Santa Rita Mountains and the old Spanish mining town of Tubac on the Santa Cruz River. They purchased the 17,000-acre Arivaca Ranch with 25 silver mines, and the Sonora Exploring and Mining Company was incorporated in Ohio with a capital stock of $2 million. Maj. S.P. Heintzelman was president, with Edgar Conkling as general agent, Poston as commandant and managing agent at Tubac, Brunckow as geologist, mineralogist, and mining engineer in charge of the Cerro Colorado District, and Charles Schuchard in charge of "La Aribac and Smelting Haciendas."

Brunckow left the Sonora Exploring and Mining Company, which was plagued by financial and management issues in later years, to develop his own enterprise. He formed the San Pedro Silver Mine on the San Pedro River southwest of what is now Tombstone. Brunckow and a small group of miners built a cabin and small store on the site. In July 1860, the store was robbed, livestock was rustled, and at least three men were killed. Mining in the area stopped until well after the Civil War.

The Santa Rita Mining Company was organized in 1858 to work the resources in the Santa Rita and Patagonia Mountains. By 1860, the Heintzelman mine produced about $2,500 in silver per month (about $78,000 today).

Several military posts had been established to try to protect the miners in the 1850s. Fort Buchanan had been established in 1856 in the Sonoita Creek valley to protect miners and encourage settlers south of the Gila River. Another military base, the Camp on the San Pedro River, also known as "Fort Aravaipa," "Fort Breckenridge," and "Old Fort Grant," was initially established in 1860.

Stage routes, including the semiweekly Butterfield mail route from San Antonio, Texas, to San Diego, stopped in Tucson from 1857 to 1861. During this era, prospecting and mining activity continued to increase until military protection was dramatically reduced in 1861 at the beginning of the Civil War.

The Arizona Territory was separated from New Mexico on January 12, 1862. Soon after, in 1862–1863, Capt. Joseph Walker and his party explored central Arizona and found gold in Hassayampa, Lynx, and Weaver Creeks near Prescott. Abraham Peeples's gold strike led to the development of the Weaver Mining District near Rich Hill and Wickenburg. Driven by the recent strikes in the area, the first territorial capital was established in Prescott in 1864. Despite the lack of military protection and a resulting increase in conflict with the Native population, by 1864, miners and prospectors made up about 25 percent of the regional non-Native population.

As the influence of the Civil War lessened in 1864, interest in mining in Arizona increased. In January 1865, H.H. Edgerton, an assistant engineer with the Arizona Mining Company and a photographer, made a series of stereoviews as his group returned to Southern Arizona to determine the feasibility of reopening the mines in the Aravaipa area.

After the end of the Civil War, word of the potential mineral wealth in Arizona drew prospectors throughout the territory hoping to find their own rich deposits of gold, silver, lead, zinc, and copper. Scores of small mines were founded, and those that were successful evolved into larger industrial operations in the areas where economics warranted.

The General Mining Law of 1872 provided a significant catalyst to mining in the West by making the surface and underground rights to mineral resources on federal public domain lands available for mining. The law permitted individuals and corporations to prospect on public domain lands and provided a mechanism for staking up to 60-by-1,500-foot lode (hard rock) for a fee of $5 per acre or 100-by-1,320-foot placer (gravel) mining claims for a fee of $2.50 per acre. The law provided the right for US citizens over 18 to own and work the mineral discoveries they found. It also added extralateral rights permitting the miner to follow the vein visible on the surface even if it extends underground outside of the area claimed.

In 1874, rich placer gold deposits were discovered in the Santa Rita Mountains. Like most mining in Southern Arizona, the arid climate made obtaining sufficient water for the miners and for the placers and other mining operations a significant challenge.

Changes in the efficiency of refining during this era generated flurries of activity at many locations as new techniques changed the economics of extracting minerals.

During the boom years of the 1870s into the early 20th century, the mines, miners, and adjacent communities that grew around them were documented in stereoviews, cabinet cards, and mounted photographs. Most were made by professional photographers traveling from their studios and using the bulky wet plate collodion process. Many of the images that were produced were sent to friends and families of the miners. Others were used to document investments made remotely to show the outcome of the investments and stability of the operations.

A significant impact on the possibility of making mining images underground was the ability to add light. Magnesium and potassium chlorate powder, called flash powder, became popular for interior photography in the 1860s. The light was produced by the rapid burn rate of the powder, which created heat and light. Photographers working underground used flash powder in caves and sometimes mines but needed to attend to the possible presence of gas and dust in the mine that could, and occasionally did, cause explosions.

In 1889, George Eastman introduced the Kodak camera, which used flexible roll film instead of glass plates. The portable cameras initially produced round images and required sending the camera back to Kodak in Rochester, New York, for processing. Though relatively expensive, the hand-held cameras made it much easier for amateurs to make photographs and changed the type of images that were available.

Amateur photographs and the vernacular or "snapshot" aesthetic evolved over the next 20 years. The growing interest in postcards and ability to print amateur photographs on postcard stock fueled this interest. Once again, Kodak played an important role. In 1902, Kodak began selling Velox postcard paper, and in 1903, it released the No. 3A Folding Kodak camera, which produced negatives that could be easily contact printed on the postcard paper.

The photographic images of mining in Arizona that appear in this book were produced in a variety of formats. Several early stereographs illustrate the pioneer era of the 1870s and 1880s. Cabinet cards and mounted photographs provide a view of mining from that point up to the early 20th century. Images from real photographic postcards illustrate the "Golden Years" between 1903 and just after World War I and into the 1920s.

This book presents a selection of historic images of mines and miners in Southern Arizona, both from areas well known today and others that are remembered only in these historic photographs. The subjects of the images selected range from small mining operations of the era to the precursors of the large corporate mines that eventually replaced them.

I hope you enjoy the images from my collection and the brief stories they contain about miners and mines in Arizona during the exciting era around the transition from territory into early statehood. My thanks and appreciation go to the brave pioneer photographers who left the legacy of these amazing images that help us investigate the past and explore the history of early mining in Arizona.

Three miners are shown at work underground posed around the large timbers that were used to shore up the stope ceilings and the typical ground rubble in an underground mine in about 1900. Hand drills, called "jacks," and eight-pound hammers were used to make the holes used to place explosives to blast free sections of ore. The miners worked by candlelight, using wrought-iron "Sticking Tommy" holders that could be hung on or hammered into the beams. (Silver print, identified as Bisbee area, photographer and location unknown, c. 1900. Collection of the author © vintagephoto.com.)

One

EARLY MINING IN ARIZONA

The growth of mining in Arizona was mirrored by changes in the photographic formats used to capture images of the rich history of the era. For example, many of the earliest images of Southern Arizona mines were produced as stereographs. Stereographs were made with collodion wet plate glass negatives in a camera with two lenses separated at a similar distance to human eyes. When the two images that were produced in the camera were mounted on card stock and placed in a viewer, the images fused to create a single 3D image. The small size of the camera, relatively rapid exposures, and lucrative market for sales made stereoviews popular for most early Arizona photographers. Stereoviews were popular from the 1850s into the 1930s and were the format that captured many of the images of early Arizona personalities, camps and towns, and mines.

Glass negatives were also used to make the albumen prints on 4.5-by-6.5-inch cabinet cards or larger boudoir sizes that became a popular photographic format in the 1870s. Images of Arizona mines appear in this format into the 1890s. Cabinet cards were replaced by mounted silver prints at the beginning of the 20th century.

The expansion in the development of mines in the early 20th century aligned with the popularity of the real photographic postcard. Portable cameras, roll film replacing glass plates, and changes in postal regulations made postcards the media of choice during this era. Rural Free Delivery ensured that even the small mining towns in Southern Arizona were able to send and receive postcards. Often the postcards taken in and sent from the small mining communities are all that remain.

This chapter will provide some examples of images in these early photographic formats and an overview of some vintage images of historic Southern Arizona mines and miners.

A Valley Scene in the Santa Rita Mountains, Arizona.

This detail from a stereoview published by the Continent Stereoscopic Company shows an early Spanish mining camp in the Santa Rita Mountains in the early 1880s. This image became such a popular representation of Arizona mining that many other photographers and publishers made and resold copies. Stereoviews were the format that photographers used to capture many of the important historic images of early Arizona personalities, camps and towns, and mines. Stereoviews like this were popular from the 1850s into the 1930s. (Photographer unknown, c. 1880. Collection of the author © vintagephoto.com.)

This is one of the earliest photographs of the Arizona Territory discovered to date. As the Civil War conflict decreased in the west, mining engineer H.H. Edgerton and a group of entrepreneurs came to Arizona in 1864 to explore the possibility of reopening the old Spanish mines. This image shows the casual interaction between the Papago warriors, Anglo scouts, and guide as they posed in front of old an adobe structure at Arivaca. (Detail from a stereoview by H.H. Edgerton, c. 1865. Collection of the author © vintagephoto.com.)

This view shows the primitive living quarters at the upper left and a group of miners posed on the hillside above the mine in the Santa Rita Mountains. Another group of men is working at the hillside entrance to the shaft of an old Spanish mining site. (Detail of Continent Stereoscopic Company stereoview, c. 1878. Collection of the author © vintagephoto.com.)

A group of miners is pictured as they try to extract remaining trace quantities of minerals from waste material, called tailings, at an unidentified Arizona mine. Note the mine buildings, rail track, and wooden hopper to load ore from the mine onto wagons at the top and right rear of the image. (Detail of silver print, photographer and location unknown, c. 1898. Collection of the author © vintagephoto.com.)

This view shows a miner's living quarters and "works" of the Aztec Mining Company about 15 miles southeast of Wilcox on the northeast side of the Dos Cabezas Mountains in Cochise County. The two wagons at center likely carried the unidentified photographer, supplies, and other visitors to the remote camp. (Detail from a stereoview by the Continent Stereoscopic Company, photographer unknown, c. 1880. Collection of the author © vintagephoto.com.)

This example of a primitive miner's camp shows his lean-to living quarters near the Coronado Mine about two miles west of Metcalf. Originally discovered by Julius Freudenthal and Morris Leszynsky in 1874, the mine produced copper and was later absorbed by the Morenci branch of the mining operations of the Phelps Dodge Corporation. (Detail of silver print, photographer unknown, c. 1901. Collection of the author © vintagephoto.com.)

This Arizona mining tableau shows two men watching another use a simple pan to wash sand and gravel to separate gold particles in the foreground. At the right rear of the image, a miner works his cradle, or "rocker box," that was used to separate gold from sand and gravel in placer mining. (Detail from boudoir cabinet card by Frank Hartwell, location unknown, c. 1890s. Collection of the author © vintagephoto.com.)

This image made by an unidentified photographer caught three miners working in close quarters underground. They are at work using candles held in wrought iron "Sticking Tommy" holders. Note the axe they used to fit the huge wooden beams to shore up the mine shaft. (Silver print, photographer and location unknown, c. 1890s. Collection of the author © vintagephoto.com.)

A miner and an assayer with his loupe magnifier pose in a studio looking at the mold samples used to calculate the value of ore per ton. The assayer pulverized the sample, melted and fused it in an assay furnace, poured the resulting metal into a mold, then when it cooled, calculated the potential yield per ton of the ore sampled. (Detail of cabinet card, photographer and location unknown, c. 1880s. Collection of the author © vintagephoto.com.)

This elaborate mining tableau illustrates several steps involved in the mining process in the West. At right are a primitive early *arrastra* (mill) and steam-powered mill used to crush the ore. Given the arid location near Yuma, the tanks at the top probably hold water or leaching chemicals. At the left is a furnace used to refine and produce the ingots of metal stacked in front. At the far left is a man, possibly the owner, overseeing the process. Images like this were sent to remote investors to provide evidence of their investments and the productivity of their properties. (Boudoir cabinet card, photographer and specific location unknown, c. 1880s. Collection of the author © vintagephoto.com.)

Captioned on the reverse, "This is a picture of the bars of bullion that I made last month, about $70,000 worth. The manager's little girl and the Mexican who guards the bullion coming out to the Railroad." (Silver print from Arizona album, photographer and location unknown, c. 1900. Collection of the author © vintagephoto.com.)

Many of the images that capture life in the emerging mining communities in Arizona were taken by itinerant photographers or by established local photographers who traveled to the new mines as they became productive. This burro with its lumber load was too big to fit into the traveling photographer's studio tent. Note the panel of sample photographs by the tent "door." This outdoor portrait shows some of the town of Metcalf in the background. (Real-photo postcard, Metcalf, Arizona Territory, photographer unknown, c. 1910. Collection of the author © vintagephoto.com.)

18

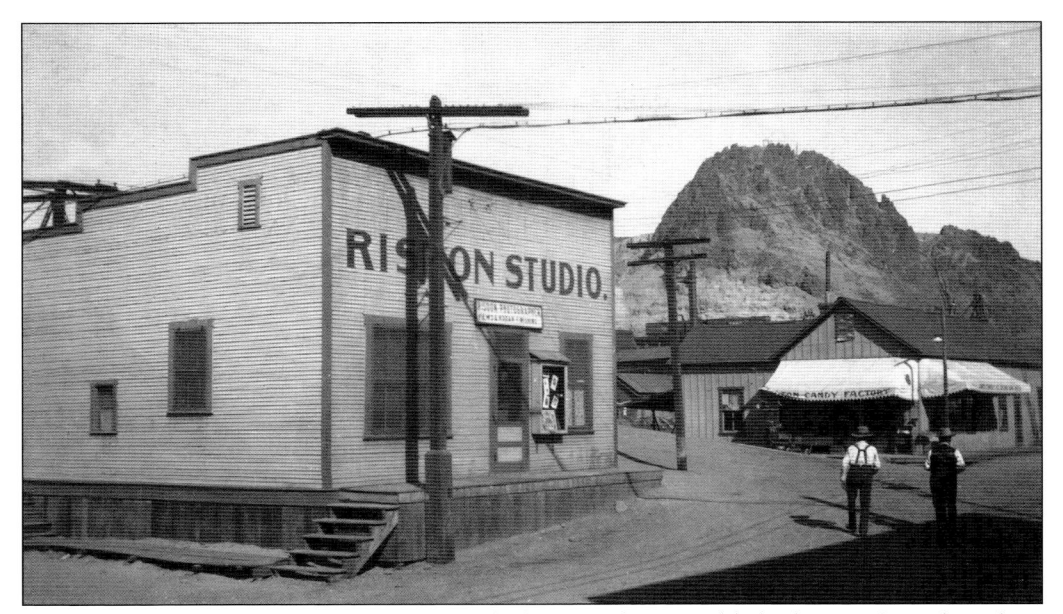

As the communities grew, entrepreneurial photographers established more formal studios. Photographers followed the markets in the towns as the population around the mines and smelters grew. This view shows the photographic studio O.C. Risdon established in Clifton after mining activity in Metcalf began to decline. (Real-photo postcard, Clifton, Arizona, photograph likely by O.C. Risdon, c. 1912. Collection of the author © vintagephoto.com.)

This view shows two unidentified men decked out as miners. For their studio portrait, they brought in their faithful dog, a well-used pick, a pan, and some rich "color" to imply that their efforts had been successful. (Real-photo postcard, photographer unknown, c. 1910. Collection of the author © vintagephoto.com.)

This dramatic view looking down the railroad tracks shows the pumping head works of the massive leaching plant that was constructed in 1917 to support the mining operations at Ajo. The image was taken during final construction just before the plant began operations in May 1917. (Real-photo postcard, photograph likely by Dale T. Mallonee, c. 1917. Collection of the author © vintagephoto.com.)

Two

Ajo

Though the Tohono O'odham Native Americans and Spanish had mined the area for centuries, interest in the old mines in the Ajo Mountains increased substantially after the Gadsden Purchase following the end of the Mexican War. Tom Childs, who had explored the area, shared his experience with Peter Rainsford Brady in Tucson in 1850. In 1853, Col. Andrew Gray led a survey team that included Peter Brady through the area for a proposed Texas Western Railroad line that was planned to cross Arizona en route to California. The surveyors brought copper ore from the area to San Francisco, which led to the creation of the Arizona Mining Company in 1854. They shipped the copper, gold, and silver ore through Yuma to San Diego, where it was shipped around Cape Horn to Swansea, Wales, for processing. A smelter was built on-site but was not able to operate successfully. The remote operations, remaining conflicts with the Mexican government, and high cost of shipping led to the mining operations closing in 1859.

Tom Childs surfaces once again in partnership with Washington M. Jacobs when the partners build a mining camp at Ajo in 1884. The efforts were mildly successful, with ore sent first by wagon, then by rail to San Francisco for processing. The partners sold their operation to the St. Louis Copper Company in 1898. Despite a new mill, the company went bankrupt within a few years.

A series of financial and technical investments by other operators, including the New Cornelia Copper Company, General Development Company, Ajo Copper Company, and Tharsis-York Company, failed. A new mining technique, the open pit, was seen by John C. Greenway of the Calumet & Arizona Mining Company in Bisbee as a possible solution to successfully producing copper at Ajo. Initial test drilling for ore began in 1911. The Tucson, Cornelia & Gila Bend Railroad began construction of a standard-gauge rail connection to Ajo in 1915. A $7.5-million chemical and electrolytic leaching plant to process the carbonate copper ore was constructed in 1916. Ajo became the first open pit mine in Arizona in 1916.

This view, labeled "Cleveland Ave., Ajo, Ariz," shows the primitive living conditions for miners during the early days before mining operations expanded with the advent of the open pit mine. In the early 20th century, new chemical and electrolytic leaching and refining processes fostered the growth of mining operations at Ajo. (Real-photo postcard, photographer unknown, c. 1912. Collection of the author © vintagephoto.com.)

This view shows the shaft and equipment of the original New Cornelia Copper Company mine at Ajo. After several unsuccessful experiments with Fred McGahan's "vacuum smelter" and the "Anderson Process" to refine unusual carbonate Ajo copper ore, in 1911, the mine was sold to the Calumet & Arizona Mining Company, which had been operating at Bisbee. (Real-photo postcard, photograph likely by Dale T. Mallonee, c. 1917. Collection of the author © vintagephoto.com.)

As mining operations continued, the town of Ajo initially grew slowly. Water was a limiting factor despite finding a potential source near the Childs railroad siding a few miles north of the townsite. This view shows the beginning of an Ajo business district. (Real-photo postcard, photographer unknown, c. 1912. Collection of the author © vintagephoto.com.)

Traditional operations started to grow after metallurgist Louis D. Ricketts, mine manager John C. Greenway, and geologist Ira Joralemon built a new chemical and electrolytic leaching plant that could successfully process the copper ore from the Ajo mines. This view shows the mining operation with temporary buildings and businesses in the foreground. (Silver print, photographer unknown, c. 1914. Collection of the author © vintagephoto.com.)

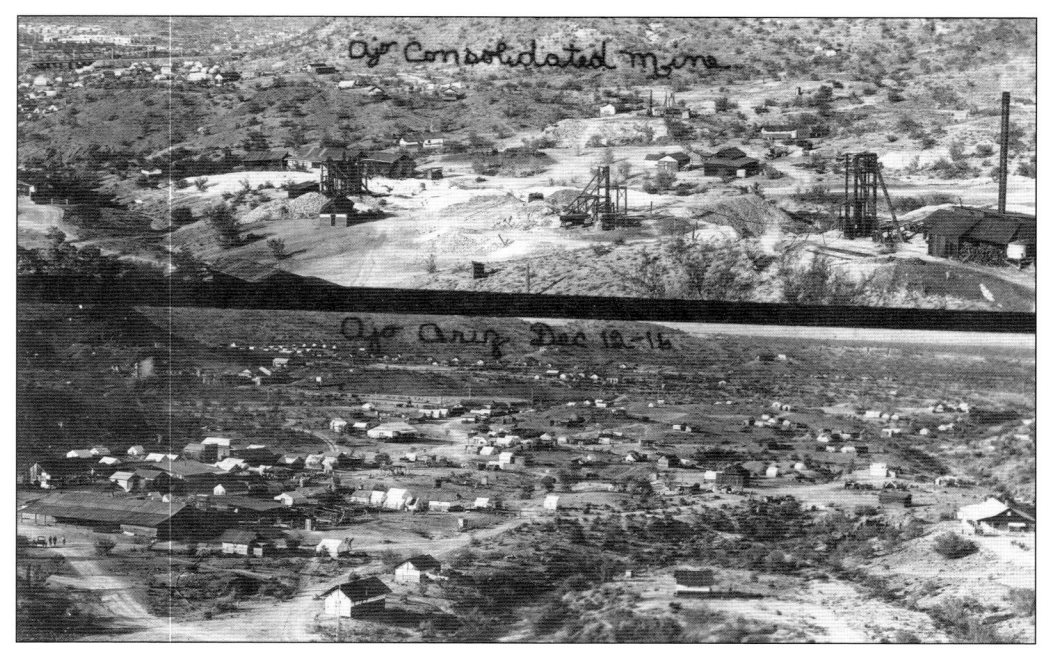

The top panoramic photograph shows the expanding above-ground mining operations of the Ajo Consolidated Mine. The lower panoramic view shows the rapid growth of the town of Ajo as miners flooded the area as the mines expanded and built temporary shelters. (Real-photo postcard, photograph likely by Dale T. Mallonee, c. 1916. Collection of the author © vintagephoto.com.)

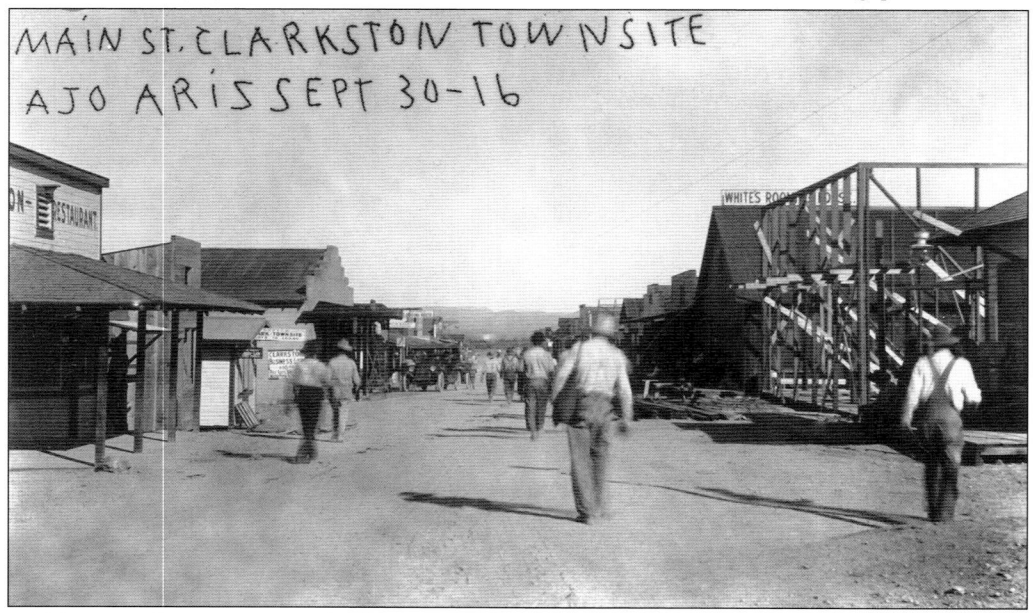

Building on the excitement that grew around the mines at Ajo, a new town, Clarkston, grew adjacent to the New Cornelia and Ajo Consolidated Mines. The town was named for Sam Clark, who became known as "the daddy of Clarkston." Clarkston grew at a phenomenal rate. The *Arizona Republican* noted that "during the first 60 days, 250 buildings were erected." (Real-photo postcard, photograph likely by Dale T. Mallonee, c. 1916. Collection of the author © vintagephoto.com.)

The main street continued to add new businesses, including the Cornelia Hardware Company, Keating Brothers Jewelry Store, Valley Lumber Company, Tom Child's grocery, Miners and Merchants Bank, Clarkston Plumbing and Tinning Company, and Pioneer Bakery. The population grew dramatically. The *Arizona Republican* noted that "sites have been set aside for churches, schools and a post office." (Real-photo postcard, photograph likely by Dale T. Mallonee, c. 1916. Collection of the author © vintagephoto.com.)

Other businesses that opened during the initial boom at Clarkston included several restaurants and rooming houses, two ice cream parlors, two grocery stores, a milk depot, ice delivery, a laundry, a bathhouse, a fuel and feed yard, a cigar store and newsstand, a theater, a pool hall, and a second-hand store. The residents of the "New town of Clarkston adjoining Cornelia" petitioned for a post office on April 6, 1916. (Real-photo postcard, photograph likely by Dale T. Mallonee, c. 1916. Collection of the author © vintagephoto.com.)

The initial success of using leaching to process the ore at Ajo led to the construction of a massive new chemical and electrolytic leaching plant in 1916. This view shows the construction of the new plant well underway in November 1916. (Real-photo postcard, photograph likely by Dale T. Mallonee, c. 1916. Collection of the author © vintagephoto.com.)

This is a view of the construction of the new $7.5-million chemical and electrolytic leaching plant at Ajo from the northeast. This image shows the active construction site in November 1916. (Real-photo postcard, photograph likely by Dale T. Mallonee, c. 1916. Collection of the author © vintagephoto.com.)

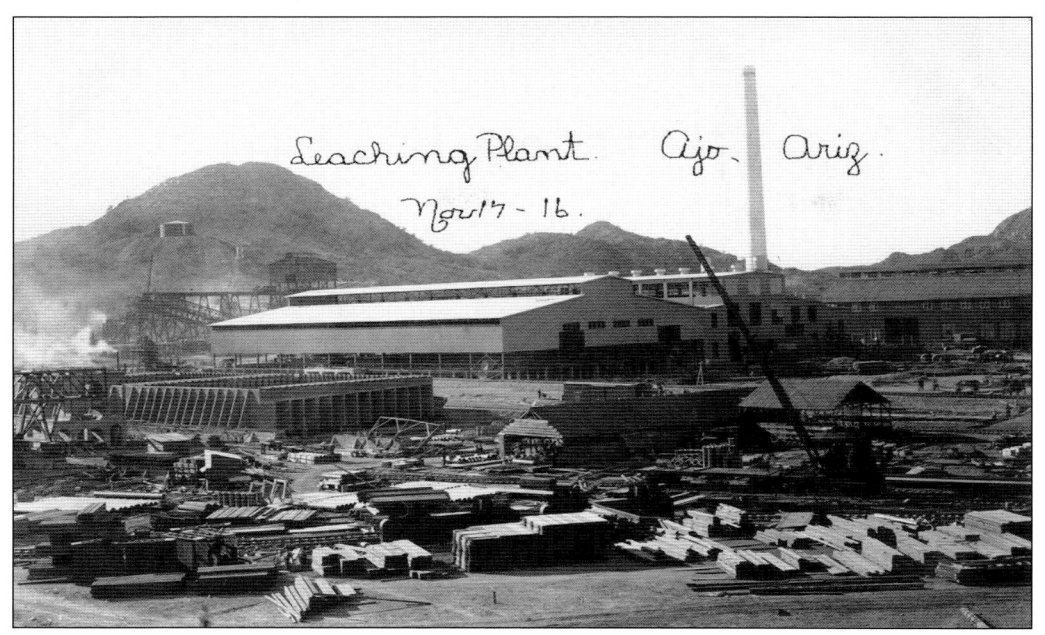

Active construction continued at a rapid pace to complete major sections of the plant. This image shows the end of the construction of the new $7.5-million chemical and electrolytic leaching plant at Ajo. (Real-photo postcard, photograph likely by Dale T. Mallonee, c. 1916. Collection of the author © vintagephoto.com.)

The massive overall mining operations and support services at Ajo continued to develop very quickly. This construction scene only a month later shows the framework of the new company store and freshly laid railroad rails in the foreground. (Real-photo postcard, photograph likely by Dale T. Mallonee, c. 1916. Collection of the author © vintagephoto.com.)

The open-pit mining operation produced so much ore that 18 steam locomotives were needed to haul the ore from the pit to the ore crusher associated with the smelter. This scene shows one of the New Cornelia Copper Company engines pushing a train of heavily loaded ore cars. (Real-photo postcard by Walter T. Hadsell, c. 1920. Collection of the author © vintagephoto.com.)

The primitive roads throughout Arizona during this era made travel challenging. The smooth, reliable railroad infrastructure and the gentle slopes of the railroad beds needed by the loaded locomotives offered far superior travel. This extended open White touring car was outfitted with wheels to ride on the rails between regular locomotive traffic. (Silver print, photographer unknown, c. 1920. Collection of the author © vintagephoto.com.)

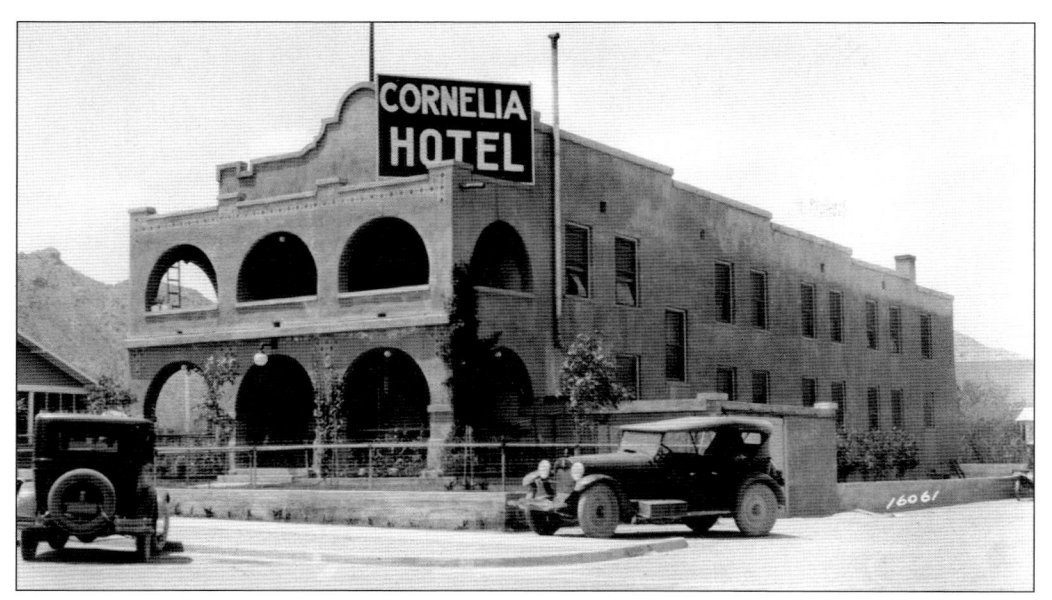

The Cornelia Hotel was built at 300 La Mina Avenue in response to the exploding demand for housing as the mining operations at Ajo expanded in 1916. The Spanish Colonial Revival–style building featured a dramatic two-story arched porch at its front that could also serve as a sleeping porch. (Real-photo postcard, photographer unknown, c. 1918. Collection of the author © vintagephoto.com.)

The town of Ajo grew as quickly as the mining operations. This view shows a busy downtown scene in front of the Tucson, Cornelia & Gila Bend Railroad depot that was built in 1916. (Silver print, photographer unknown, c. 1920. Collection of the author © vintagephoto.com.)

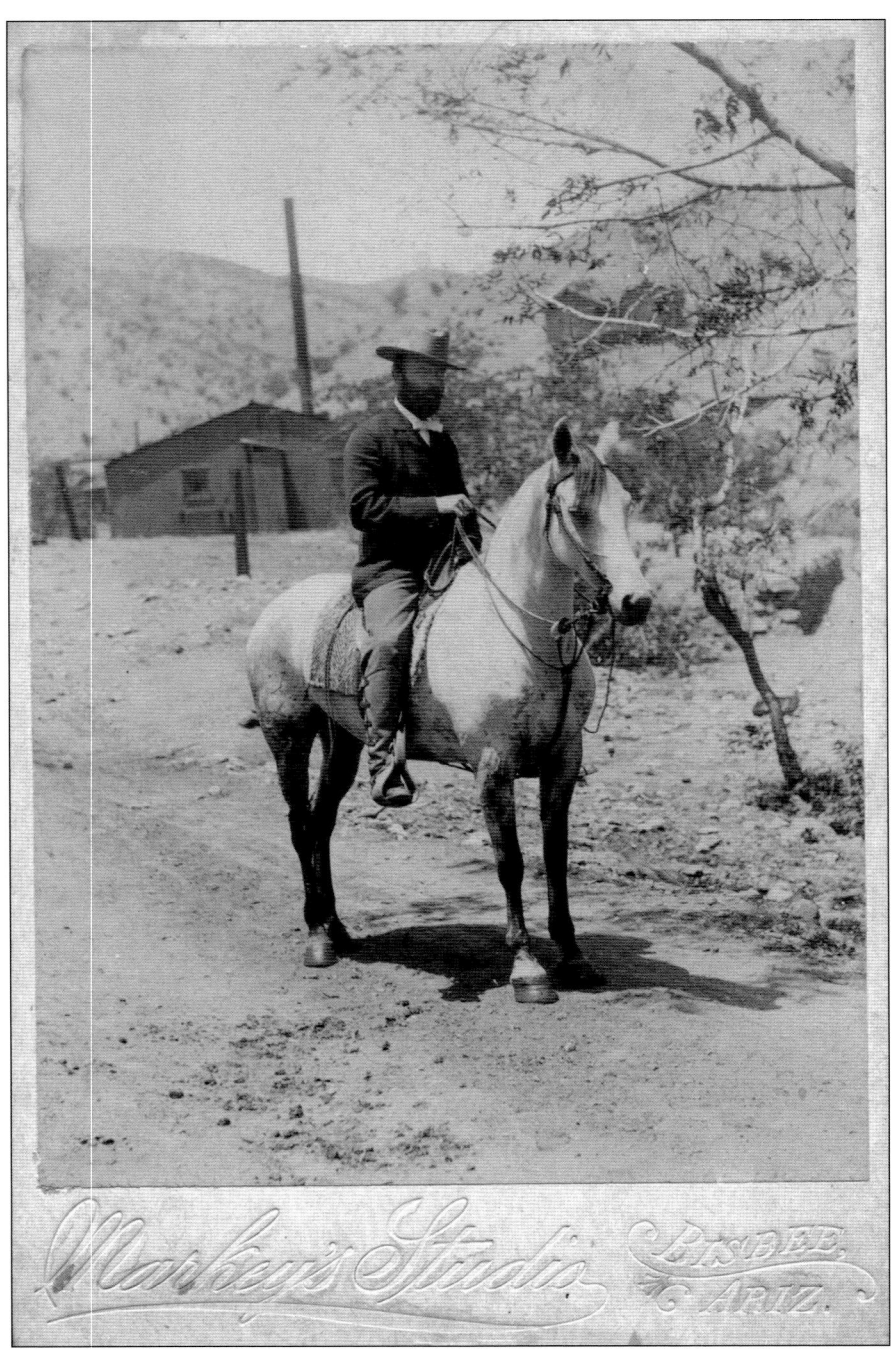

This portrait is identified as a tragic but little-known figure in Bisbee history. Dr. Ernest G. Carleton was born in British India and came to Bisbee in February 1896 to work as a doctor at the Copper Queen Consolidated Copper Company hospital. Ernest was well known and well liked but suffered from "despondency, due to excessive work," according to the *Bisbee Daiy Review*. Carleton committed suicide in Morenci with a pistol shot to his head on October 20, 1902. (Cabinet card by Daniel Markey, c. 1900. Collection of the author © vintagephoto.com.)

Three

BISBEE

Like many other Southern Arizona mining communities, though prospectors visited the area in the 1860s, development begins in the late 1870s when military scouts discovered copper in the Mule Mountains. Lt. Jack Dunn and prospector George Warren staked mining claims that sparked the local boom in about 1877. Just a few years later, Warren lost his share of the Copper Queen in a drunken bet that he could outrun a horse and rider over a 100-yard course in Charleston, Arizona Territory.

Initially, the town that developed was called Mule Gulch, and mining focused on gold and silver. Copper production began with the Copper Queen Mine, established in August 1880. The Phelps Dodge Company purchased another mine, the Atlanta, in 1881 and then merged with the Copper Queen in 1885. The railroad reached Bisbee in 1889. The Calumet & Arizona and Shattuck-Arizona mining companies joined Phelps Dodge with significant operations at Bisbee in the early 20th century.

Bisbee's mines, with the rich copper ore, and after the early 1880s, smelters fueled its rapid growth. Initially, Bisbee was a rough Western mining town and home of over 50 saloons, gambling halls, and houses of prostitution in 1900. Bisbee grew rapidly, roughly doubling in size between 1899 and its incorporation in 1902 with a population of about 8,000.

Bisbee added amenities to be more than just a mining town. The Copper Queen Hotel opened in 1902, the same year women were banned from saloons. The Bisbee Opera House was designed by Henry C. Trost in 1906 and opened on July 24, 1907. Local architect Frederick C. Hurst designed the new building for the post office and dramatically expanded the library that opened in March 1907. Electrical power, telephones, and a streetcar line linking Bisbee with Warren were added in 1908.

Fire and water periodically ravaged Bisbee. After demand from the smelters stripped vegetation from the hills, Bisbee became prone to flooding. Significant floods occurred in July 1890 and August 1896. In 1908, Bisbee had an August flood and a great fire in October that destroyed over half the business district. Other fires and floods continued to plague Bisbee.

Open-pit mining started in 1917. Eventually, the Sacramento Pit and, later, the Lavender Pit absorbed portions of the town. Bisbee weathered copper price fluctuations and other challenges and continued as a mining community until the 1970s, when it made a successful transition to a historic community.

News quickly reached even the remote Western mining communities via travelers, telegraph, letters, and newspapers. This stereoview image was taken in the Bisbee area showing a large group of miners in a memorial parade for President Garfield after his assassination on September 19, 1881. (Detail of stereoview by George Rothrock, c. 1881. Collection of the author © vintagephoto.com.)

This group of men moving large rocks in a construction site was identified as being in Bisbee. It is possibly a scene taken during the modification of the Copper Queen smelter in about 1894. (Albumen print, photographer unknown, c. 1890s. Collection of the author © vintagephoto.com.)

Most camps in Arizona faced challenges in providing adequate water for both mining operations and for their growing population. Bisbee was no exception. This image shows the Hispanic water carriers and their burros loaded with bags of water that would be delivered to miners' homes and businesses. (Boudoir card by Willis P. Haynes, c. 1900. Collection of the author © vintagephoto.com.)

Sports and competitions between mining communities provided diversions to the grueling work schedules. This image shows the huge crowd that gathered to watch a two-man "double jack" mining competition to see which team could drill the deepest hole with an eight-pound sledgehammer and steel drill in 15 minutes. (Albumen print, photographer unknown, c. 1900. Collection of the author © vintagephoto.com.)

The rapid development of mine operations did not always include effective engineering and robust construction. This image shows the attempt to move an ore train back onto the tracks after an accident at the Copper Queen Mine. Note the tenuous foundations for the railroad that ran along the edge of the mine. (Albumen print, photographer unknown, c. 1900. Collection of the author © vintagephoto.com.)

Over 3,000 Bisbee and Warren residents turned out for the opening day of the Warren Bisbee "Streetway" that opened on March 12, 1908. Seven electric trolley cars operated on the route between Warren, Bakersfield, Upper Lowell, and Bisbee. (Boudoir card by Willis P. Haynes, c. 1908. Collection of the author © vintagephoto.com.)

These classic Bisbee images were so iconic they were used as gambling illustrations with incorrect association with many other communities. The image above shows well-heeled residents at a roulette wheel. The image below shows a busy Bisbee faro table gambling scene in 1907. (Silver prints, photographers unknown, c. 1900 [above] and 1907 [below]. Collection of the author © vintagephoto.com.)

This group of miners underground, in the Copper Queen Mine, is unloading the hoist car cage that carried them and their supplies into the mine. Note the heavy timbers, supply of steel rock drills, and damp and muddy working environment. (Real-photo postcard by Ben Cooley, c. 1910s. Collection of the author © vintagephoto.com.)

These miners pose underground with their mule-powered ore cars. Note the massive wooden construction and two pairs of rails. The man on the right holds a classic miner's candlestick. The photographer used artificial flash to light the scene. (Real-photo postcard, photographer unknown, c. 1910s. Collection of the author © vintagephoto.com.)

These three miners pose with their powerful pneumatic jackleg drills, invented by Simon Ingersoll in 1871. Pneumatic power slowly replaced hand drilling to make the 30 to 40 ten-foot-deep holes the miners needed to blast ore free. The name "jackleg" came from a telescoping leg that permitted miners to move and place the drill. Instead of hand-holding the heavy drill, the jackleg provided a mount and brace for the air-powered drill as it rotated the drill shaft. The massive vertical column was secured in place to hold the drill. Its steel rock bits drilled the holes that were used to place the explosives used to blast lose the ore. (Real-photo postcard by Ben Cooley, c. 1910s. Collection of the author © vintagephoto.com.)

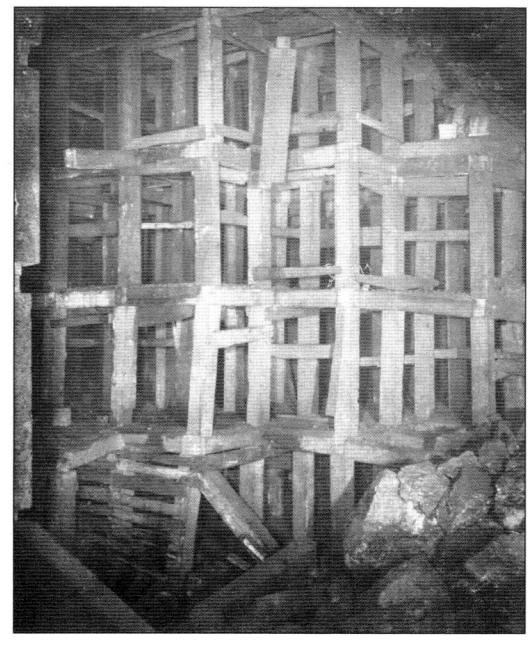

This image shows the huge wooden infrastructure or "cribbing" needed to support the rock above the areas in the stope or room left when the ore had been removed. Remember that these massive beams needed to be harvested at a distance, hauled by rail to the mine, lowered by the headframe, and carried to the open area in the mine before construction could begin. (Real-photo postcard, photographer unknown, c. 1910s. Collection of the author © vintagephoto.com.)

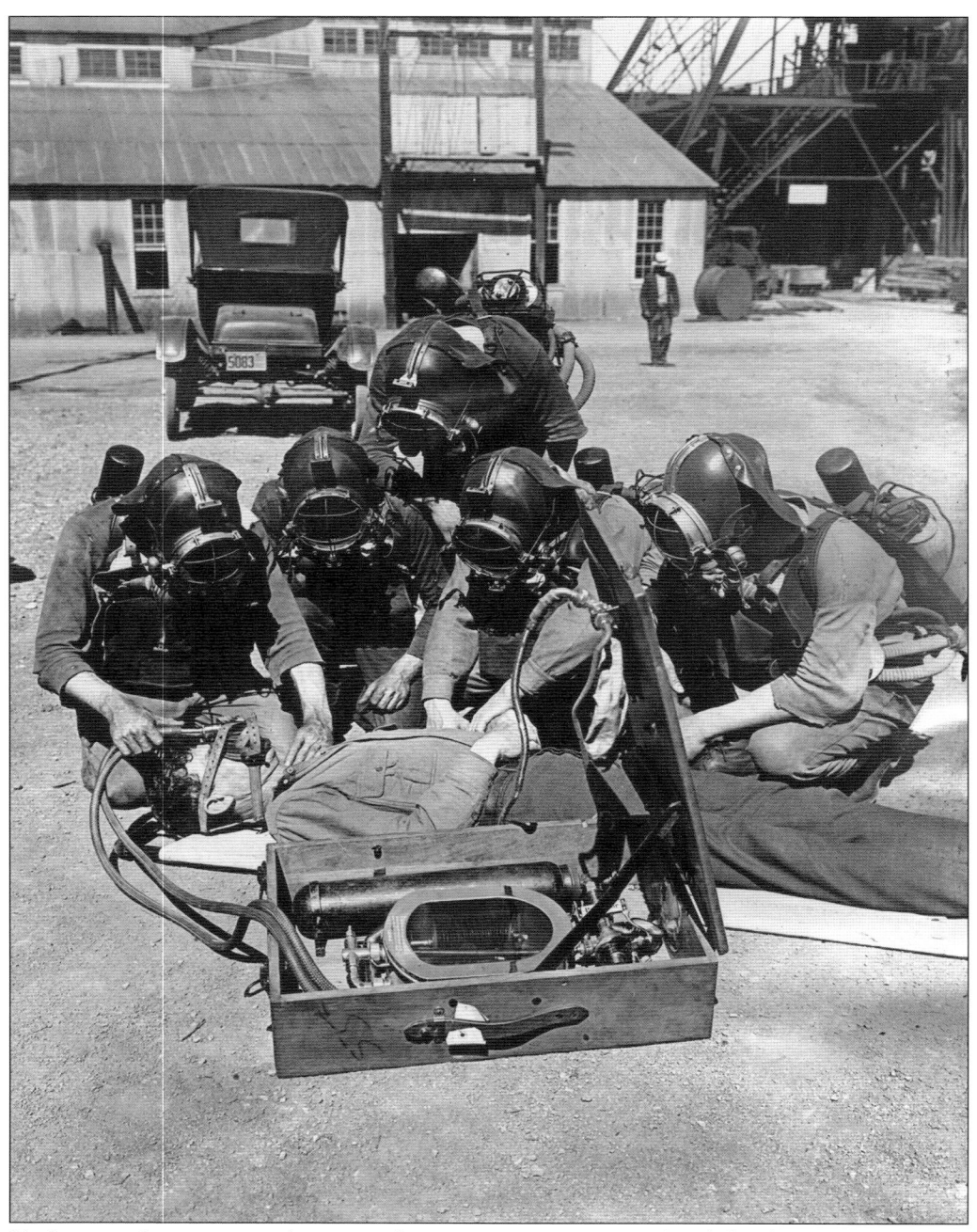

Underground mining was dangerous for many reasons. Miners faced the threat of equipment-related injury, falling rocks and cave-ins, and issues related to insufficient oxygen and natural gas accumulation. This team is demonstrating a mine rescue using a new generation of protective breathing equipment. (Silver print, photographer unknown for Underwood & Underwood, c. 1915. Collection of the author © vintagephoto.com.)

C. Q. Power House

This building was the Copper Queen powerhouse, which was constructed to provide the mechanical and electrical power for the mine. It became the powerhouse for the Warren–Bisbee Railway and provided electricity for the town of Warren in addition to the mine. In 1908, its power was provided by 300-kilowatt and 500-kilowatt Westinghouse-Parsons electrical generators. (Silver print, photographer unknown, c. 1910s. Collection of the author © vintagephoto.com.)

Despite the arid environment, flooding underground plagued many mines in the Southwest. In 1904, the Calumet & Pittsburgh (C&P) Mining Company struck water, filling the shaft with about 2,400 gallons per minute. This view shows a close-up of an operator with the water pumps built by the Prescott, Scott & Company Union Iron Works of San Francisco that were installed at the 900-foot level in an attempt to drain the mine so operations could continue. (Detail of stereoview by Olaf P. Larson, c. 1904. Collection of the author © vintagephoto.com.)

This Bisbee scene shows a sign painter, a carpenter, and a load of lumber tied to mules for delivery into the hills surrounding the town where wagons could not reach. Note the unidentified photographer with his camera taking a picture of the loaded mule train. (Silver print, photographer unknown, c. 1908. Collection of the author © vintagephoto.com.)

This detail of a stereoview is labeled the Calumet & Pittsburgh and Gardner Mine. The view looks over the headframe and mine down a canyon to Bisbee in the distance at the right. (Detail of stereoview by Olaf P. Larson, c. 1904. Collection of the author © vintagephoto.com.)

One of the early mines, the Holbrook, was originally patented in 1884 by Alphonse Larzard and Horace Jones. It was acquired by Phelps Dodge in 1888 and became one of the best-known mines in the region. This view shows the substantial slag heap and a line of miners en route to work in the mine. (Real-photo postcard, photographer unknown, c. 1910s. Collection of the author © vintagephoto.com.)

The Junction Development Company started the Junction Shaft in the Warren Mining District in 1903. In 1906, the mining operation was acquired by the Superior & Pittsburg Copper Company. (Real-photo postcard, photographer unknown, c. 1910s. Collection of the author © vintagephoto.com.)

In the foreground are two men working to unload ore from the railroad cars. Across the tracks is the Matte Yard of the Copper Queen Mine, where the ingots from initial refining were removed from the molds after cooling. (Detail of stereoview by Olaf P. Larson, c. 1904. Collection of the author © vintagephoto.com.)

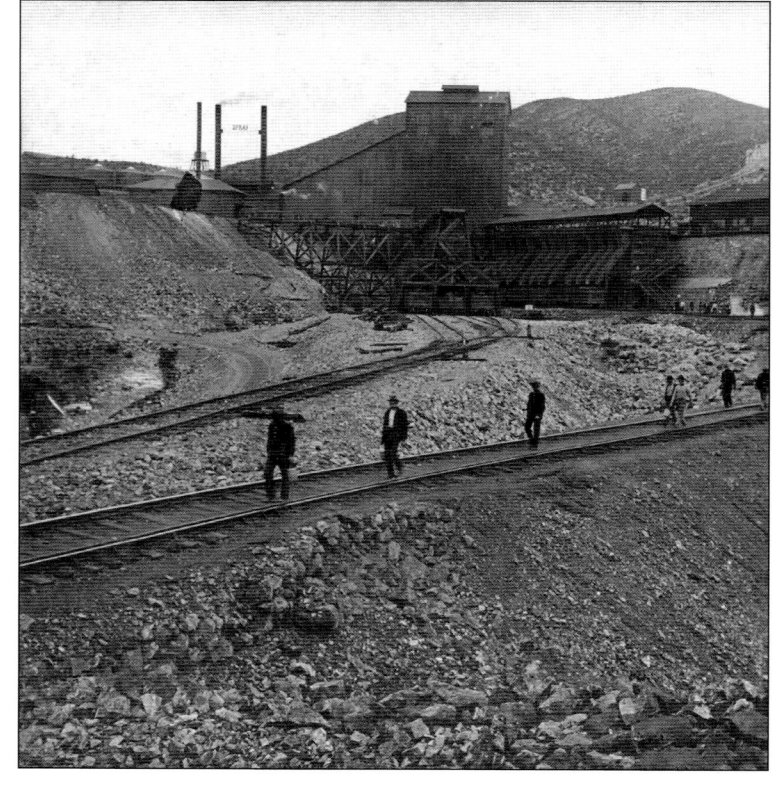

The Spray Shaft was begun above the Holbrook Mine in 1899 and hit ore in 1900. Despite several underground fires, the mine was productive until 1914, when it was closed, the works were disassembled, and the shaft was covered. (Detail of stereoview by Olaf P. Larson, c. 1904. Collection of the author © vintagephoto.com.)

Coal and wood fires used for cooking and warmth and kerosene lighting did not mix well with the rapidly constructed wooden buildings in the mining communities. When fires hit, they spread rapidly, often with catastrophic results. This view shows men fighting an early-morning fire in the hills above Bisbee on June 29, 1907. (Real-photo postcard, photographer unknown, c. 1907. Collection of the author © vintagephoto.com.)

Fires were severe enough that even brick and steel buildings that replaced the wooden structures were at risk. This view shows what is left of downtown Bisbee after the October 14, 1908, fire. (Real-photo postcard, photographer unknown, c. 1910s. Collection of the author © vintagephoto.com.)

After heavy rains, floodwater often tore down the steep canyons and streets of Bisbee. This view shows the damage done as the floodwater washed away the upper level of the roadway. (Real-photo postcard, photographer unknown, c. 1910s. Collection of the author © vintagephoto.com.)

Floods in Bisbee also impacted the city services like the trolley. In this image, trolley car 103 is going slowly over a temporary bridge across an area that had been washed out by the flooding. (Real-photo postcard, photographer unknown, c. 1910s. Collection of the author © vintagephoto.com.)

Before being outlawed in 1912, cock fighting was a popular betting sport in the mining communities of Southern Arizona. These men and boys are gathered for an outdoor cock fight with the hills of Bisbee in the background. (Silver print, photographer unknown, c. 1905. Collection of the author © vintagephoto.com.)

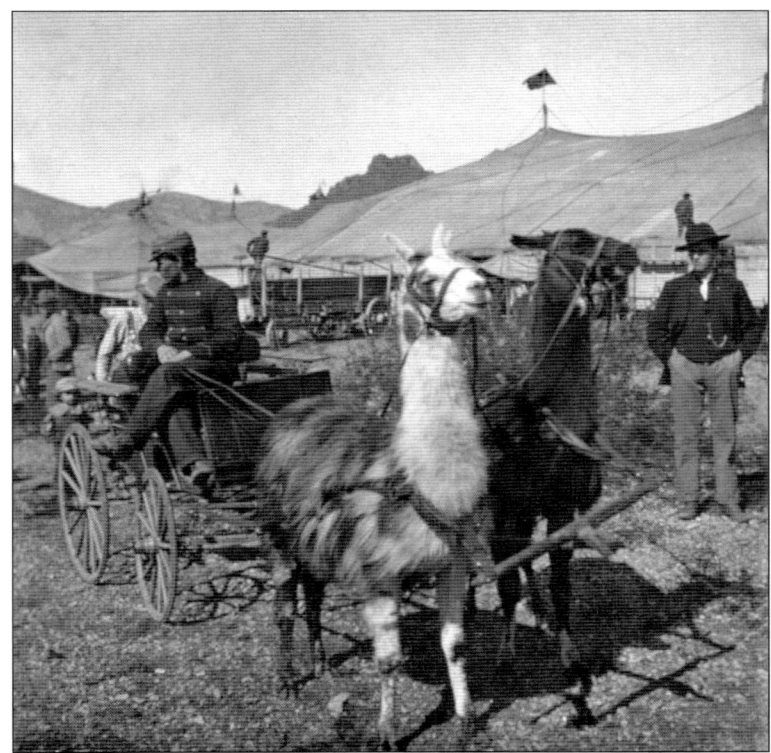

Even though Bisbee was remote, its connection by rail and significant population made it a destination for entertainment ranging from theater and circus to opera. This image shows a cart drawn by a pair of llamas, probably part of the Floto Circus, which raised its tents at Naco in March and early April 1904. (Detail of stereoview by Olaf P. Larson, c. 1904. Collection of the author © vintagephoto.com.)

The Airdome was an open-air motion picture theater in Warren. The central projection area was built like a bunker due to the highly flammable nitrate film used during the silent film era. A smooth concrete wall in front of a large open seating area was used as the projection surface. The exterior walls were built to limit viewing to only the paid patrons inside. (Real-photo postcard, photographer unknown, c. 1915. Collection of the author © vintagephoto.com.)

Soon after pro-union miners with the Industrial Workers of the World called a strike in June 1917, on July 12, 1917, Sheriff Harry Wheeler (second from right) deputized almost 2,000 company miners. Beginning in the early morning hours, they rounded up over 1,100 union men to run them out of town on railroad cars, eventually leaving them in the desert near Columbus, New Mexico. (Real-photo postcard, photographer unknown, c. 1915. Collection of the author © vintagephoto.com.)

This image shows Sheriff Wheeler's deputies rounding up the pro-union miners with the post office and library in the background. The men that had been deputized can be identified by their white armbands. (Real-photo postcard, photographer unknown, c. 1917. Collection of the author © vintagephoto.com.)

This image shows the line of armed deputies marching the deportees down the railroad tracks from Bisbee to Warren. In Warren, they were held in the baseball stadium before being herded onto railroad cars and deported by rail from Bisbee to Columbus, New Mexico. (Real-photo postcard by George C. Dix, c. 1918. Collection of the author © vintagephoto.com.)

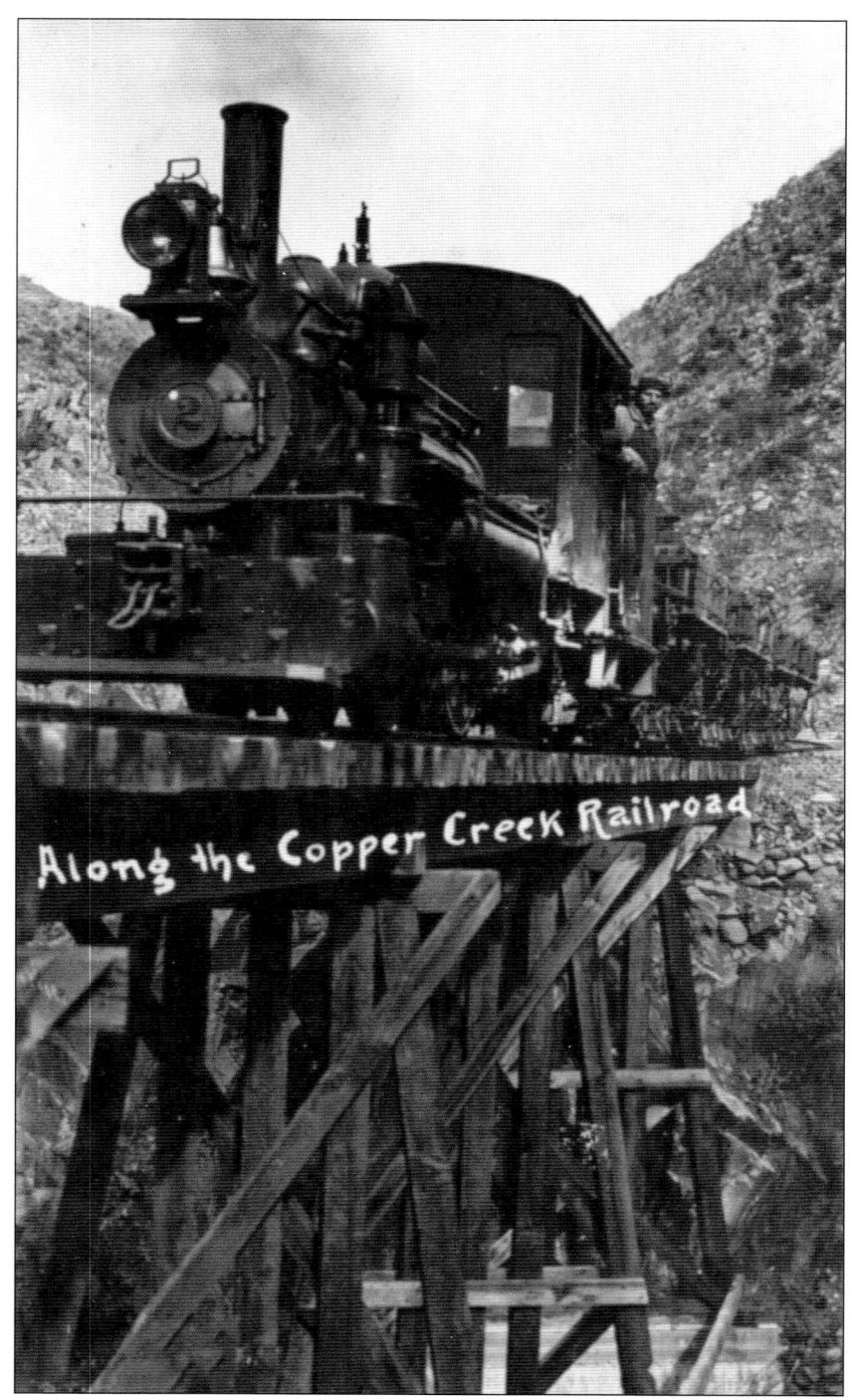

Narrow-gauge Porter locomotive engine No. 2 was acquired from the Ray Consolidated Copper Company to transport ore across the canyon. The engineer is posed leaning from the cabin on the railway trestle leading from the Copper Creek Mine. (Real-photo postcard, photographer unknown, c. 1914. Collection of the author © vintagephoto.com.)

Four

COPPER CREEK

Copper Creek is in the Galiuro Mountains in the southeast corner of Pinal County near Arivaipa Valley. This area produced silver as early as 1863, when ore was initially hauled overland to Yuma and then shipped by sea to Wales for reduction.

A group of prospectors—William N. Miller, Theodore H. Peters, and Ely H. McDaniels—formed the Copper Creek Mining District and staked several claims including the Blue Bird, General Lee, and Superior mining claims in May 1880 in Tombstone. Initially, the ore was carried by horseback to Benson for refining. Squabbling among the other owners of the claim limited further development for over 20 years.

Interest in extending railroads from Tucson through the San Pedro Valley generated new interest in the Copper Creek area. Frank J. Sibley found investors in Chicago and organized the Copper Creek Mining Company in 1903. By 1905, about 49,000 pounds of copper had been produced by the 90 men who worked in the mines at Copper Creek. The Copper Creek Post Office was established on March 6, 1906.

In 1910, the Copper Creek Mining Company was incorporated with Sibley as general manager. Though plans for a railway were revived, a railroad to connect Copper Creek to the outside world was never built.

By March 1912, the concentrator at Copper Creek was expanded, and a dam was constructed to provide power for a milling operation. But ore still had to be hauled overland to Winkelman for processing, so improved transportation around Copper Creek was needed. In April, construction started on a narrow-gauge railroad within Copper Creek Canyon to link the town, mines, and mill.

In January 1913, Sibley purchased a Porter-built narrow-gauge locomotive, eight dump cars, and a flatcar from the Ray Consolidated Copper Company in Winkelman. Two large wagons were lashed together, and the locomotive was loaded and secured on top for the final trip overland to Copper Creek.

The railway operated for about a year, linking the town, mines, and mill via a series of switchbacks on its steep hillside roadbed.

The Calumet and Copper Creek Copper Company went bankrupt in 1914. The Calumet & Arizona Mining Company tried to reopen the mine in 1914, and the Copper State Mining Company tried again unsuccessfully in 1915. The Arizona Molybdenum Corporation eventually purchased the Copper Creek Canyon claims and successfully operated the mines until 1939, when operations were discontinued and the mining facilities were dismantled.

BUY
COPPER CREEK
(SIBLEY)
STOCK
NOW

POINTER NUMBER 51.

The Copper Creek Mining Company could sell its entire stock in 30 days if it would accept first-class Los Angeles and Southern California real estate in exchange for stock. The company will not make any such exchanges, selling stock for cash only. If any Copper Creek stockholder wants first-class real estate for his stock at par he can trade for some of the following, which have been offered us within the past ten days:

1. Block of 7 stores and 24 apartments, newly built, cor. Temple and Echo Park Road, fronting 140 feet on the park, equity $12,000.
2. Equity $3500 in $7500 residence, So. Figueroa.
3. Equity $10,000 in $15,000 stores, Central Ave.
4. Two acres with artesian well, Springdale, $4000 clear.
5. Six acres, Mesto Station, $3000 clear.
6. Lot, Garfield Ave., Pasadena, $2400.
7. Equity $4500 in $8500 house, So. Figueroa.
8. Venice lot, $1500 clear.
9. Santa Monica house and lot, $1500 clear.
10. Long Beach ocean front lot, 80x220, near A. D. Meyers' palatial residence, $16,000 clear. Also other property.

Copper Creek mill will be in operation before many weeks. The Company will then mill its rich ore, making a product always salable at good prices. This means constant dividends to Copper Creek stockholders. Copper Creek Mines produce sulphide ores, the kind that is permanent and has never been worked out. Mines of this kind have continued from the earliest history to the present and are still producing and furnishing one of the greatest sources of income known. Get Copper Creek stock now and have a sure income. Buy this stock before the mill is operating. You can buy Copper Creek stock now at $1 per share. Immediately after the mill starts the price of stock will advance. Put Copper Creek down in your memory strong enough to get the advantage of its merit.

Large mill photos 432 So. Spring in window with our ore display. Office nearby, 905-6 Security Bldg.

This advertisement was placed in the *Los Angeles Herald* by Copper Creek Mining Company president Frank J. Sibley on August 22, 1909, to generate interest in investing in Copper Creek stock. Note the reference to the "Large Mill Photos" and ore display. (Collection of the author © vintagephoto.com.)

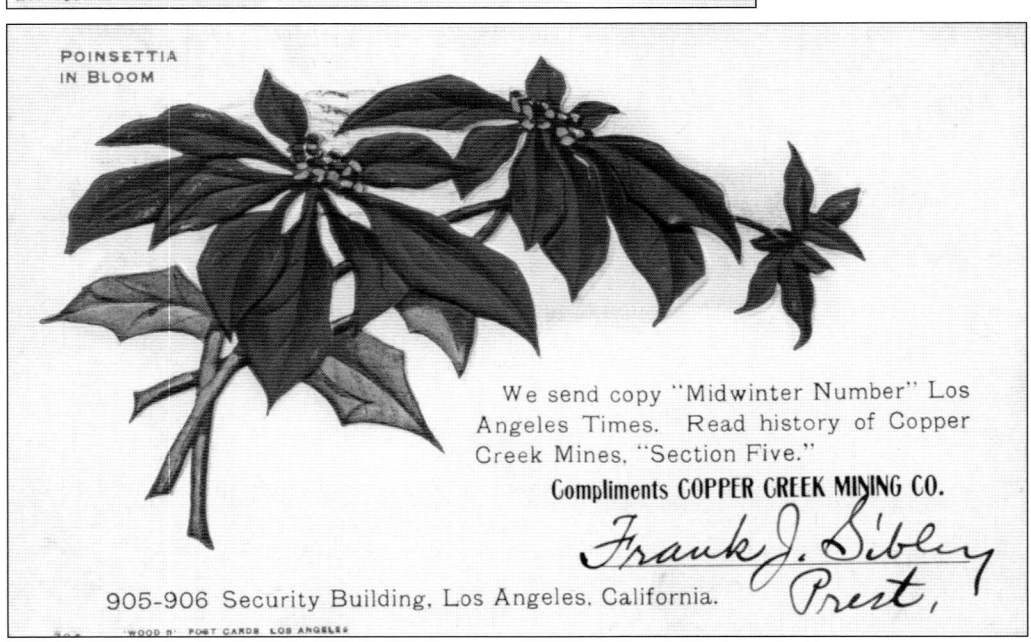

POINSETTIA IN BLOOM

We send copy "Midwinter Number" Los Angeles Times. Read history of Copper Creek Mines, "Section Five."

Compliments COPPER CREEK MINING CO.

Frank J. Sibley Prest,

905-906 Security Building, Los Angeles, California.

This promotional postcard was sent by Copper Creek Mining Company president Frank J. Sibley to promote an article about the mine. The text references an article that appeared in the *Los Angeles Times* supplement "Midwinter Number" in January 1910. (Postcard, c. 1910. Collection of the author © vintagephoto.com.)

Bringing freight to the Store at Copper Creek, Ariz.

This view shows a heavily loaded wagon delivering goods to the remote commissary and office building at the Copper Creek Mining Company on Sycamore Flats above Copper Creek. Frank J. Sibley was the president and mining operations manager. (Real-photo postcard, photographer unknown, c. 1912. Collection of the author © vintagephoto.com.)

This well-dressed group of residents is posed on the porch in front of the commissary and office building of the Copper Creek Mining Company. At the time, Robert Tew was the manager of the general merchandise store. (Real-photo postcard, photographer unknown, c. 1913. Collection of the author © vintagephoto.com.)

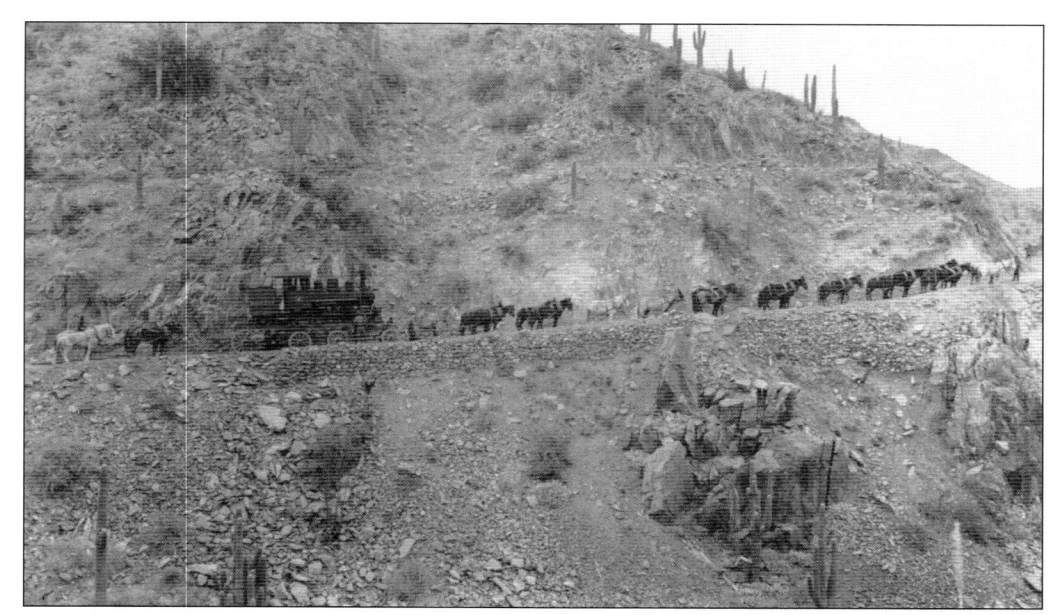

Several wagons and teams were needed to transport the narrow-gauge railroad engine No. 2 that had been purchased from the Ray Consolidated Copper Company. This view shows the teams and wagons en route on the primitive roads between Winkelman and Copper Creek. (Real-photo postcard, photographer unknown, c. 1913. Collection of the author © vintagephoto.com.)

This scene shows miners loading ore (probably at the Old Reliable Mine) at Copper Creek. Note the Ray Consolidated Copper Co. identification still appears on the tender car behind the little locomotive. This R.C.C. Co. logo was soon replaced with C.&C.C.M. Co. for the Calumet & Copper Creek Mining Company. (Real-photo postcard, photographer unknown, c. 1913. Collection of the author © vintagephoto.com.)

This dramatic image shows the interior of a machine room that supplied power to the mines for hoists and other equipment at the Copper Creek Mine in the Bunker Hill District in Pinal County. The engineer is tending the steam engine that powers the large flywheel. The short exposure almost freezes the motion of the piston, but the spokes of the fast-spinning flywheel are blurred and almost disappear. (Real-photo postcard, photographer unknown, c. 1915. Collection of the author © vintagephoto.com.)

This interior view shows an operator with a 60-horsepower gasoline engine in the shaft and engine house building at the main shaft at the Copper Creek Mine. The engines were used to raise and lower miners and ore and power generators to create the electricity that powered the camp. (Silver print, photographer unknown, c. 1920s. Collection of the author © vintagephoto.com.)

Operations at Copper Creek opened and closed as market prices changed. This view shows eight men at work at the entrance of the No. 1 Shaft of the Copper Creek Mine. At the time, the No. 1 Shaft had been extended to a depth of about 225 feet. (Silver print, photographer unknown, c. 1920s. Collection of the author © vintagephoto.com.)

This view from the northwest shows five men posed adjacent to the headframe, mine shaft, and engine house building at the No. 2 Main Shaft of the Copper Creek Mine. It soon became clear that the ore was not rich enough to support productive commercial mining operations. (Silver print, photographer unknown, c. 1920s. Collection of the author © vintagephoto.com.)

This view from the west shows several miners posed adjacent to the headframe, mine shaft, and engine house building at the No. 2 Main Shaft of the Copper Creek Mine. In 1933, interest in a new mineral, molybdenum, generated renewed interest in the mines at Copper Creek. (Silver print, photographer unknown, c. 1920s. Collection of the author © vintagephoto.com.)

Three miners are posed at the top of the ore dump below the engine house building at the No. 2 Main Shaft of the Copper Creek Mine. Despite the relatively rich ore, the remoteness of the operation and the high cost of transporting the ore during this era combined to limit mining activity in the area. (Silver print, photographer unknown, c. 1920s. Collection of the author © vintagephoto.com.)

This group of four burros was loaded to carry mining supplies from the town to mines during the early days of Courtland. Note the typical attachment of long pieces of lumber that were dragged behind the mules and the ratio of the canvas and wooden buildings to recently established more formal wooden structures. (Real-photo postcard, photographer unknown, c. 1910. Collection of the author © vintagephoto.com.)

Five

COURTLAND

The mines and town of Courtland were located about 15 miles northeast of Tombstone at the foot of the Dragoon Mountains. Beginning in 1908, the Great Western, Calumet & Arizona, Copper Queen, and Leadville copper mines drew hundreds of people to form a tent city along the road between Gleeson and Pearce. The Courtland Post Office was established in March 1909.

Two railroads soon began construction to connect to the growing town of Courtland. The Arizona and Colorado Railroad (A&C), part of the Southern Pacific Railroad, built a spur line west to Courtland from the line being built south from Pearce to Douglas. The Mexico & Colorado Railroad (M&C), part of the El Paso & Southwestern Railroad, built its own tracks to Courtland from Douglas.

A water supply for the growing communities around Courtland was stabilized in 1911, about the time the town reached its peak. During the relatively short boom, the town of Courtland included a full range of businesses, including its own newspaper, the *Courtland Arizonan*, published by W.A. Sherwood. Several general stores, including John Cull's and Charles Renaud's stores, the Turquoise Hotel, Charles Perry's bakery, two soft drink establishments (Luce & Tucker and John Bartini), a shoemaker, a barber, a telephone exchange, and at least one saloon, operated by W.S. Campbell, were other businesses that called Courland home during its boom. The private ownership of most of the businesses in the Courtland communities, as opposed to the more typical mining company corporate ownership, made Courtland unusual.

During World War I, the mines hit limestone at the 300-foot level, which led to decreasing ore quality and productivity. Like most of the copper communities in the Southwest, the challenges of declining copper prices in the 1920s were a final blow to Courtland, as the mines were abandoned and the population moved on.

Double line awaiting the Opening sale of Lots Courtland

This view was taken at Courtland on February 24, 1909, and shows over 130 people waiting to bid on the lots that were auctioned by the Courtland Development Company in the opening sale of homesites at the new townsite. Word of the rich ore at Courtland spurred a boom, which developers took advantage of as they platted and sold lots. (Real-photo postcard, photographer unknown, c. 1909. Collection of the author © vintagephoto.com.)

This overview was also taken at Courtland on February 24, 1909, and shows the crowd that gathered during the auction of lots by the Courtland Development Company in the opening sale of homesites. Prices for the lots ranged from $10 to $100. Immediately after the auction, offers of up to $200 were made to purchase some of the prime lots. (Real-photo postcard, photographer unknown, c. 1909. Collection of the author © vintagephoto.com.)

This scene shows the typical simple-to-construct, easy-to-move pallet and canvas dwellings that quickly popped up on the lots that were auctioned on the opening day of the new town of Courtland on March 15, 1909. Note the two headframes behind the dwellings at the right and the proximity of the new homes to the operating mines and slag heaps. (Real-photo postcard, photographer unknown. Collection of the author © vintagephoto.com.)

Activity at Courtland generated several separate townsites that competed for businesses and residential dwellings. This view shows the new development that J.N. McFate promoted as one of the four subdivisions of homes and businesses that were established on a flat area adjacent to the Courtland spur of the El Paso & Southwest Railroad. (Real-photo postcard, photographer unknown, c. 1910. Collection of the author © vintagephoto.com.)

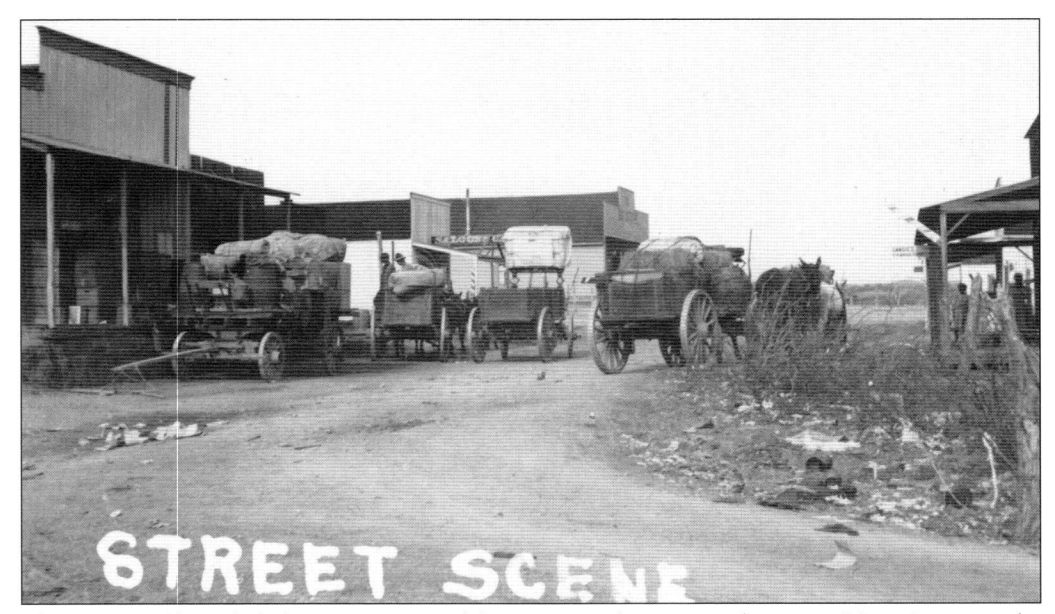

This group of heavily laden wagons was delivering supplies to merchants on Main Street in the days before the railroad was extended to reach the townsite of Courtland. Multiple townsites were established near the mine at Courtland and competed to attract new businesses and residents. (Real-photo postcard, photographer unknown, c. 1910. Collection of the author © vintagephoto.com.)

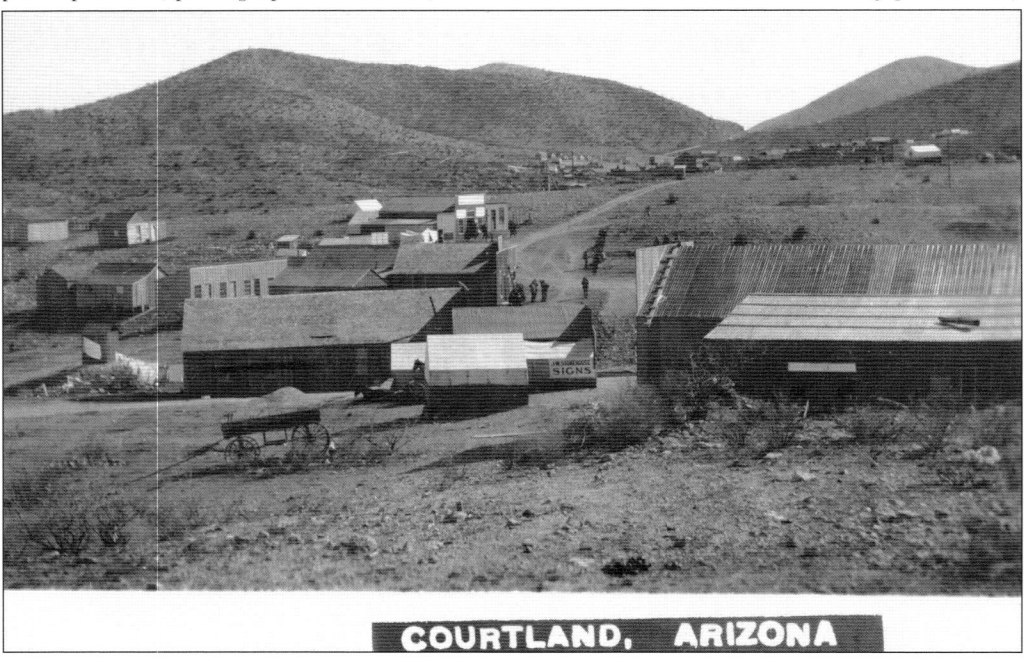

Business buildings on the main streets quickly evolved from temporary wood and canvas to more substantial wooden false fronts. This view looks across the main business section and down Main Street, showing the development of the Courtland townsite that grew adjacent to the mining operations. (Real-photo postcard, photographer unknown, c. 1910. Collection of the author © vintagephoto.com.)

This view was identified as a busy day at the Holmes train station on the south Courtland spur of the El Paso & Southwestern Railroad. This station handled passengers, ore, and freight. The El Paso & Southwestern Railroad handled ore transportation, initially to Douglas, then on to smelters in El Paso, Texas. (Real-photo postcard, photographer unknown, c. 1910. Collection of the author © vintagephoto.com.)

CENTRAL COPPER CO., DOS CABEZAS, ARIZ.

These two miners pose with their jackleg pneumatic drilling rig, which weighed about 150 pounds. The cacophonous noise and rock dust circulated by the pressurized air released by the drill made underground mining dangerous and difficult, leading to one of their nicknames: "widow makers." (Real-photo postcard, photographer unknown, c. 1923. Collection of the author © vintagephoto.com.)

Six

DOS CABEZAS

In the 1860s, placer miners found gold near the Butterfield Overland stagecoach stop at Ewell Springs on the southwest side of the Dos Cabezas (Spanish for "two heads") Mountains in Cochise County. Mining activity was relatively insignificant until 1880, when the Southern Pacific Railroad reached Wilcox about 14 miles to the northwest. A boom town followed, quickly reaching a population of 300, with 50 adobe buildings housing Mrs. Bricklin's hotel, Cory & Porter's and J.M. Riggs general stores, blacksmith P.A. Boyer, several saloons, liquor stores operated by A.S. Athay, A.C. Richards, Rodgers & Chattman, and Wood & White, and three stamp mills to process ore.

Copper soon replaced gold as the mineral of choice. The Dos Cabezas Consolidated Mines Company was formed in the early 20th century, and Thomas McCauley formed the Mascot Copper Company in 1907. The company invested over $1 million from 1909 to 1914 in equipment and developing infrastructure. A new townsite was established on February 11, 1914, in Mascot Canyon near the Consolidated Mine tunnel, and additional independent investors began operating in the region.

The 10-mile-long standard-gauge Mascot & Western Railroad was built to connect Dos Cabezas and Mascot with the Southern Pacific Railroad at Wilcox. The final copper spike was driven on June 15, 1915, as construction was completed with about 4,000 guests attending the huge barbeque that celebrated the arrival of the railroad and new townsite at Mascot.

A series of photographs and postcards were produced showing the mining-related equipment and activities and life in the town to help promote the various mining operations in the area.

Despite the railway and significant investments in the area, the next decade never saw the population grow much over the 360 persons in the 1920 census. In 1924, the Central Copper Company assumed ownership of 56 mining claims, including the Mascot Copper Company, the Mascot Townsite and Reality Company, the Mascot & Western Railroad, and about 100 buildings on the properties, including employee housing, the general store, the power plant, and related equipment. Though mining remained a primary focus, raising cattle grew as another local industry. Like many Southern Arizona peers, soon the mines closed, people moved on, and Dos Cabezas became a ghost town.

The Mascot Copper Camp housed miners, administrators, and equipment near the mine. This overview shows the road that led to the administrative offices in the general camp at the Mascot Mine and the cluster of miners' quarters that flowed up the gulch that extends to the left from the center of the image. (Real-photo postcard, photographer unknown, c. 1915. Collection of the author © vintagephoto.com.)

Though equipment, materials, and supplies came by rail from Wilcox to Dos Cabezas, wagons provided the "last mile" transportation for deliveries to the mine. Before the railroad, ore was carried over rough roads to the railhead at Wilcox by wagons and later by a Pierce-Arrow truck. Two heavily laden wagons are shown on the road between Dos Cabezas and the general camp at the Mascot Mine. (Real-photo postcard, photographer unknown, c. 1923. Collection of the author © vintagephoto.com.)

The offices and administrative buildings and homes for mine administrators of the Central Copper Company were constructed on the steep sides of the mountains and required significant foundations. The building at the upper left has elaborate wooden trusses holding its porch. Other buildings show substantial concrete and river rock foundations. (Real-photo postcard, photographer unknown, c. 1923. Collection of the author © vintagephoto.com.)

Like many mining communities, the company provided company stores that sold food and household goods and often offered other community amenities. This view shows the company store next to the recreation hall on the road below the Central Copper Company camp at Dos Cabezas. (Real-photo postcard, photographer unknown, c. 1923. Collection of the author © vintagephoto.com.)

Several of the images produced to promote the Central Copper Company investments at Dos Cabezas used artificial light to capture underground scenes. Here, a miner poses near the electrical controls for the mine lighting and signals to alert miners about shift changes and emergencies. (Real-photo postcard, photographer unknown, c. 1923. Collection of the author © vintagephoto.com.)

This scene shows two miners underground in the "cage" of the skip car that the hoist would carry to the surface. The ore car positioned at the left is filled with "ore" to imply productive operations. The miner's carbide lamp in the hand of the gentleman on the ladder traces his movements from the time the camera shutter was opened until the flash was ignited. (Real-photo postcard, photographer unknown, c. 1923. Collection of the author © vintagephoto.com.)

CENTRAL COPPER CO., DOS CABEZAS, ARIZ.

Steam or electric power was used to run the air compressors that fed the pressurized air required for the powerful pneumatic jackleg drills. This view shows the compressor, pressure controls, and a set of rock drills. (Real-photo postcard, photographer unknown, c. 1923. Collection of the author © vintagephoto.com.)

As ore was removed, large timbers were used to shore up the ceilings to prevent cave-ins. This view shows a set of massive timbers adjacent to the rail used by ore cars far underground at the Central Copper Company mine. (Real-photo postcard, photographer unknown, c. 1923. Collection of the author © vintagephoto.com.)

This tableau was set up for the camera to show a busy scene of miners and administrators of the Central Copper Company. The photographer posed the large group of miners with a loaded wagon on the road between the mine and Dos Cabezas. (Real-photo postcard, photographer unknown, c. 1923. Collection of the author © vintagephoto.com.)

This Ingersoll Rand Imperial Type 10 steam-powered air compressor dates from the 1910s. It was made in New York and shipped to the Central Copper Company mine to provide compressed air to power the jackleg pneumatic drilling rigs underground. (Real-photo postcard, photographer unknown, c. 1923. Collection of the author © vintagephoto.com.)

Adjacent to the iconic vertical headframe, machine buildings were erected to house the engines, motors, and collateral equipment needed for the mining operations. This view shows the engine and generator that were used to create the electrical power needed at the Central Copper Company mine at Dos Cabezas. (Real-photo postcard, photographer unknown, c. 1923. Collection of the author © vintagephoto.com.)

This view shows the operator with the hoisting equipment that was used to raise and lower the skip car cage that carried men and equipment into and out of the Central Copper Company mine. Note the heavy cast-iron hoist base. The blurred movement shows that the hoist was photographed in operation. (Real-photo postcard, photographer unknown, c. 1923. Collection of the author © vintagephoto.com.)

The remote location of many mines made repairing broken equipment difficult. Most mines needed a local capacity to fabricate parts and execute repairs. This view shows the interior of the blacksmith shop operated by the Central Copper Company at the Dos Cabezas mine. (Real-photo postcard, photographer unknown, c. 1923. Collection of the author © vintagephoto.com.)

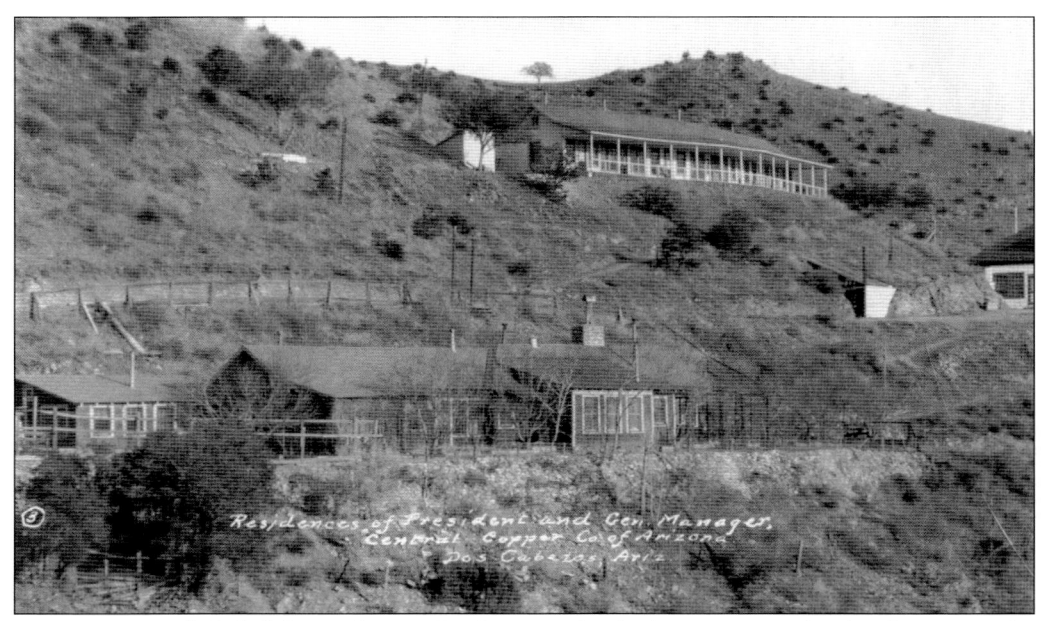

Many camps included elaborate homes for the upper-level administrators that lived onsite at the mines. This view shows the substantial home of the president and general manager of the Central Copper Company (Thomas N. McCauley at the time). (Real-photo postcard, photographer unknown, c. 1923. Collection of the author © vintagephoto.com.)

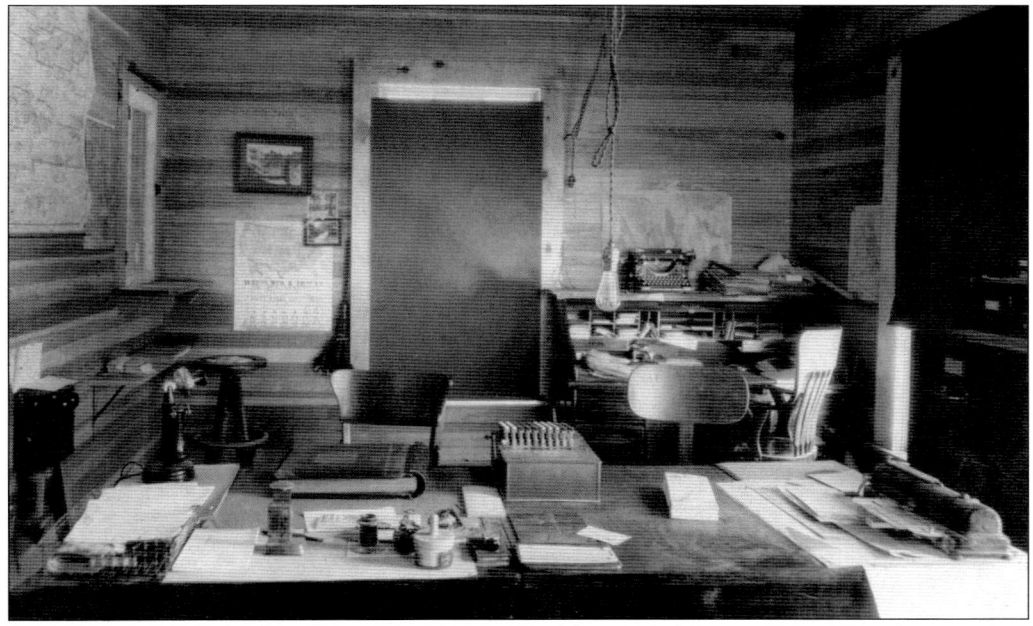

This image shows the well-organized interior of one of the Central Copper Company administrative offices at the Mascot Mine. Note the adding machine and the telephone that connected the remote mining camp to the outside world. (Real-photo postcard, photographer unknown, c. 1923. Collection of the author © vintagephoto.com.)

Schools were important in the remote mining communities of this era. Travel from Dos Cabezas to the established schools at Wilcox was impractical, so the Consolidated Copper Company added a school to its master plan. This view shows the students posed in front of the school building. (Real-photo postcard, photographer unknown, c. 1923. Collection of the author © vintagephoto.com.)

This image shows the interior of one of the upper-grade classrooms in the Central Copper Company Camp School at Dos Cabezas. The male teacher, Earl Matteson, is posed by the window on the boys' side of the room, with the male and female students separated by the aisle. (Real-photo postcard, photographer unknown, c. 1923. Collection of the author © vintagephoto.com.)

In addition to schools, the mine owners added community spaces to their master plans. This image shows a significant portion of the Dos Cabezas population in one of the community buildings, probably the recreation hall that was built adjacent to the company store. (Real-photo postcard, photographer unknown, c. 1923. Collection of the author © vintagephoto.com.)

This image shows the locally famous "Black Cat," a c. 1918 Republic Motor Truck Company vehicle that, like the White touring car at Ajo, was modified to run on the railroad tracks. Driver Lon Perkins is at left, with railroad conductor Lon Haley in the center and an unidentified passenger on the right. The Black Cat hauled personnel and light loads of supplies over the Mascot & Western Railroad that connected the Central Copper Company's Mascot Mine with Wilcox. (Real-photo postcard, photographer unknown, c. 1924. Collection of the author © vintagephoto.com.)

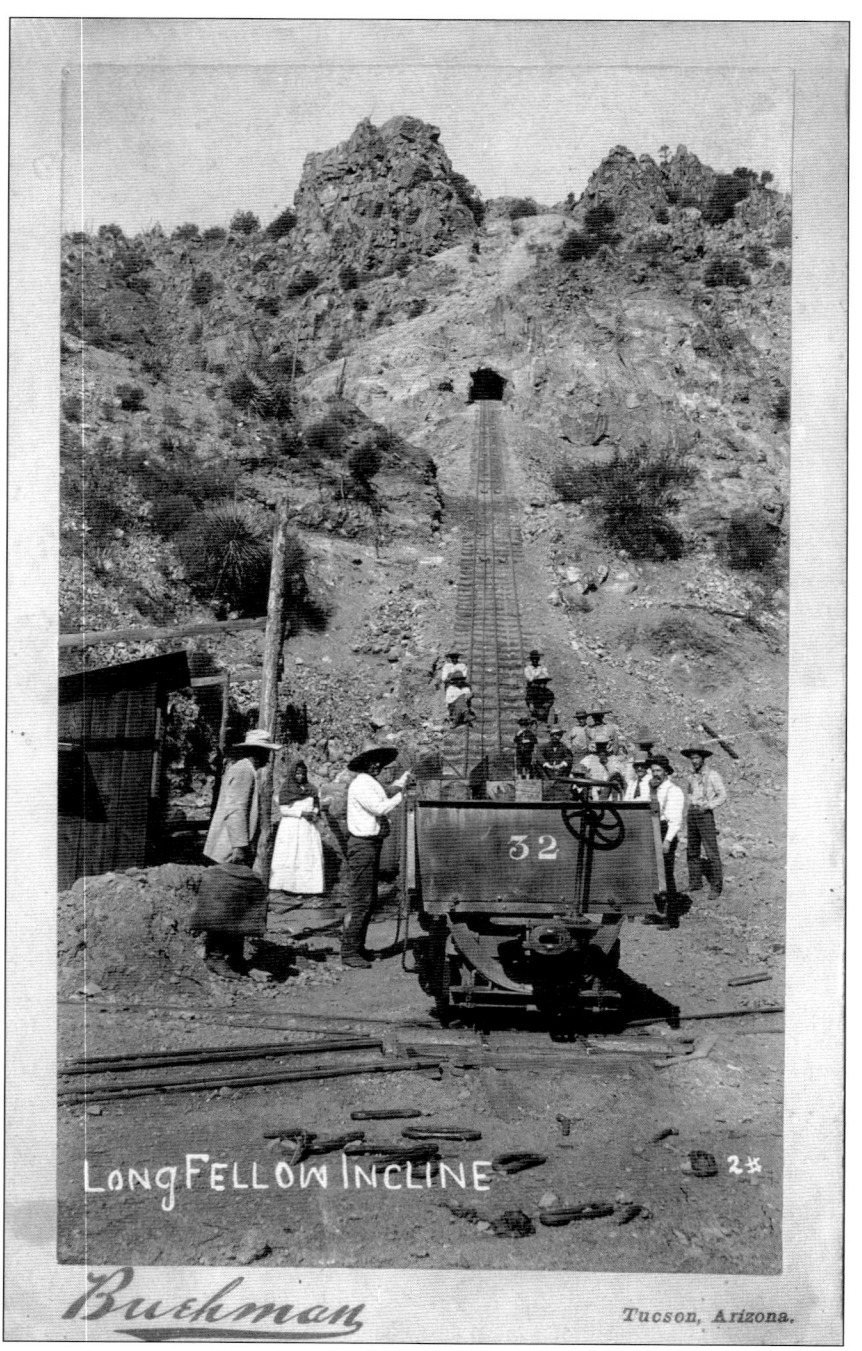

LongFELLOW INCLINE

Buehman

Tucson, Arizona.

To reach the ore high on the mountainside, several gravity incline railways, including the Coronado, Longfellow, King, Metcalf, Queen, Shannon, and Wilson inclines, were constructed to lower ore to the base of the mountains. "The Coronada," a narrow-gauge railroad engine that was later known as "Little Emma," was shipped in from Pittsburgh, Pennsylvania, to haul ore from the mines to the smelter at Clifton on the Coronado Railroad. (Boudoir cabinet card by Henry Buehman, c. 1890. Collection of the author © vintagephoto.com.)

Seven

CLIFTON, MORENCI, AND METCALF

In 1864, the recorder of the Hassayampa Mining District, Henry Clifton, traveled to the southeastern corner of the Arizona Territory. He found evidence of copper, but placer mines in the area produced little gold or silver. In 1870, Robert Metcalf, a scout and miner from New Mexico, noticed evidence of historic mines and copper outcrops on the slope of a mountain along what became known as Chase Creek. Charles and Henry Lesinsky purchased Metcalf's Longfellow Mine, which was established in 1872 a few miles up Chase Creek. In 1882, the Arizona Copper Company purchased the Longfellow Copper Mining Company mine and smelter.

In 1873, Goulding's Camp, founded in the area near the Arizona–New Mexico border at the junction of Chase Creek and the San Francisco River, changed its name to Clifton.

Southwest of Metcalf was Joy Camp, which changed its name to Morenci in 1882. Like Metcalf, the ore in Morenci was located on the side of the mountains.

In 1902, the Shannon Copper Company built a new smelter at Clifton to refine ore from Metcalf. As the smelter grew, Clifton became a business center for the region.

Graham County, which included Metcalf, Morenci, and Clifton, grew from 5,670 in 1890 to 14,162 in 1900 and reached 23,999 in 1910. Efforts of the mining companies led to the creation of Arizona's 14th county when Clifton, Metcalf, and Morenci were included in the new Greenlee County, formed in 1909.

Morenci reached a peak population of about 7,500 in 1920 before the expanding open-pit mine replaced the townsite. The Metcalf townsite suffered the same fate. Clifton reached its peak population of about 5,000 in 1910 and today is the Greenlee County seat with a population of about 3,800.

This view shows three miners with a loaded ore car on the surface of one of the mines at Metcalf. Note the lack of either horse or steam power, with miners moving the ore cars as they clean up the rails at the entrance of the mine. (Detail of stereoview, photographer unknown, published by Underwood & Underwood, c. 1903. Collection of the author © vintagephoto.com.)

This view shows two of the inclines used to bring ore from the mines down the mountains to the Coronado Railroad, which carried it from Metcalf to the smelter at Clifton. Note the inclusion of women and children in the foreground to imply that a stable, residential community had developed adjacent to the mines. (Detail of stereoview, photographer unknown, published by Underwood & Underwood, c. 1903. Collection of the author © vintagephoto.com.)

AT THE MINES METCALF ARIZ.

Roads at Metcalf were primitive and snaked up through the mountains to link the homes and mining buildings above Chase Creek. Too steep for wagons, mules carried loads of water and supplies throughout the camp. (Real-photo postcard, photographer unknown, c. 1908. Collection of the author © vintagephoto.com.)

This view shows one of the primitive roads that linked Metcalf, Morenci, and Clifton. It is easy to see why pack mules were the transportation method of choice. (Silver print by C.W. Marks, c. 1905. Collection of the author © vintagephoto.com.)

Railroads were limited in terms of the ability to carry loads up steep grades. In addition, as loads increased, the ability of the engine to pull up a slope decreased. To reach the town, the Morenci Southern Railroad had to ascend a series of gentle loops to maintain a manageable incline. This is the fourth loop the railroad constructed en route to Morenci. (Detail of stereoview by A.H. Davidson, c. 1903. Collection of the author © vintagephoto.com.)

This dramatic view shows a heavily loaded locomotive completing one of the loops en route to Morenci. Note the mine carefully framed with the town buildings scattered on top of the surrounding hills. (Detail of stereoview by A.H. Davidson, c. 1903. Collection of the author © vintagephoto.com.)

Housing for the miners was built wherever convenient, even on the hillsides. This view shows a cluster of typical wood and canvas structures that could be quickly built, then disassembled and moved to new locations as needed. (Silver print, photographer unknown, c. 1903. Collection of the author © vintagephoto.com.)

This is a close-up view of the vertical double headframe constructed at the mine in Morenci. One side appears to be dedicated to raising and lowering ore cars, with the other cage used to transport miners. (Silver print, photographer unknown, c. 1903. Collection of the author © vintagephoto.com.)

These two views show details of the mining operations at Morenci. The image above shows the double headframe, mining buildings, and railroad. The bottom image is a graphic detailed photograph of mining equipment. (Silver prints, photographer unknown, c. 1903. Collection of the author © vintagephoto.com.)

A massive concentrator was built adjacent to the mine at Morenci. This view shows the headframe at the right with the mill and concentrator buildings on the left cascading down the mountainside. (Silver print, photographer unknown, c. 1903. Collection of the author © vintagephoto.com.)

LONGFELLOW INCLINE MORENCI ARIZ.

The Longfellow Mine at Morenci added infrastructure and eventually replaced the incline and expanded its railroad connection. This view shows the rails snaking up the hill and the extensive workings that were developed at its base. (Real-photo postcard, photographer unknown, c. 1915. Collection of the author © vintagephoto.com.)

The mines of Morenci drew workmen from many backgrounds. The photographer captured this group of miners between their shifts posing dramatically with a spare cowcatcher from one of the locomotives. The cowcatcher was mounted on the front of the locomotive to deflect obstacles that might be in the tracks to help avoid derailing. (Real-photo postcard, photographer unknown, c. 1908. Collection of the author © vintagephoto.com.)

Morenci developed organically throughout the foothills. This view looks across the Detroit Copper Mining Company mining operations and slag heaps to show the rapidly growing town in the background. (Silver print by C.W. Marks, c. 1890s. Collection of the author © vintagephoto.com.)

Though labeled Clifton on the mount, this tableau of a little mule locomotive and loaded mules appears to be taken in Morenci. Clearly, the subjects are all aware of the camera and are looking at the photographer as they pose for the photograph. (Silver print, photographer unknown, c. 1903. Collection of the author © vintagephoto.com.)

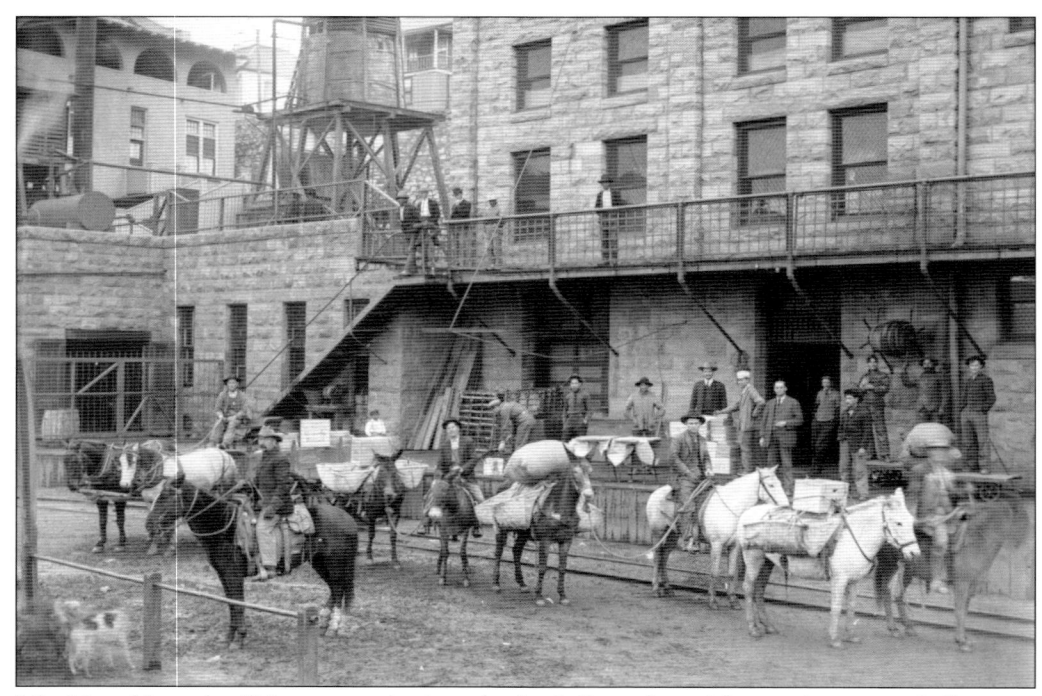

Like Metcalf, much of Morenci was built in the foothills, making deliveries by wagon challenging. This view shows both a loaded wagon and a packed train of mules ready to depart from the train depot adjacent to the Detroit Copper Company Store. (Silver print, photographer unknown, c. 1903. Collection of the author © vintagephoto.com.)

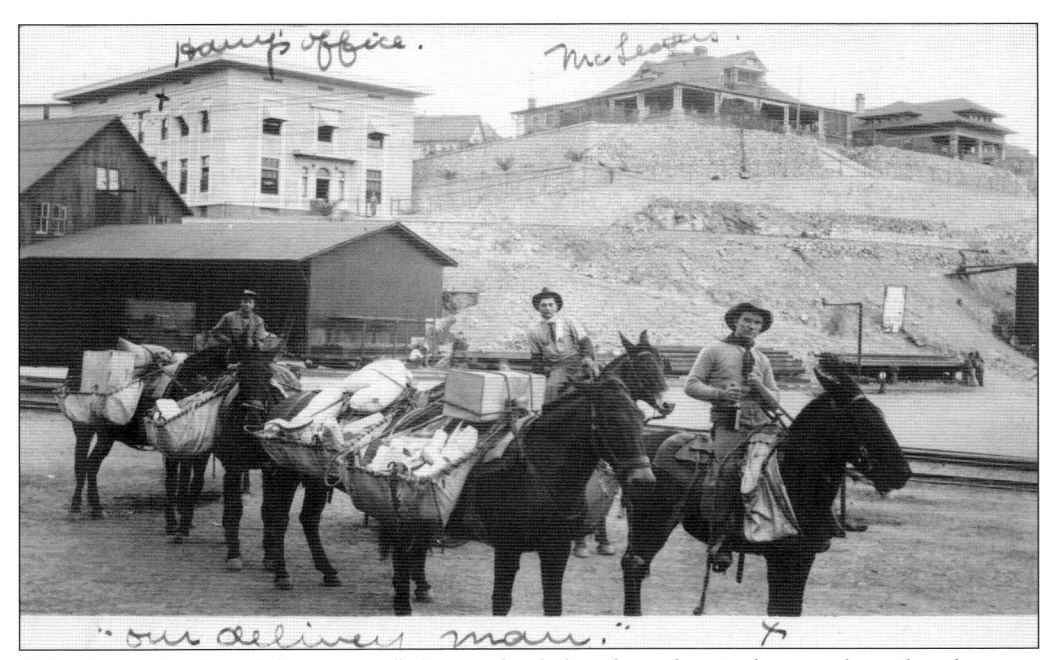

This view, titled "our delivery man," shows a loaded mule pack train leaving the railroad station to make a delivery in the foothills of Morenci. Note the bottle of spirits held by the gentleman leading the pack. (Real-photo postcard, photographer unknown, c. 1908. Collection of the author © vintagephoto.com.)

Though cock fighting was illegal, it was still a popular sport in many Southern Arizona mining communities. This image shows a group of well-dressed attendees at a cock fight at an unidentified building in Morenci. (Silver print, photographer unknown, c. 1908. Collection of the author © vintagephoto.com.)

The Arizona Rangers were formed in 1901, initially with only 12 men. As their reputation and responsibilities expanded, including intervention in mining strikes like the one in Morenci in 1902, more men joined. This image shows the rangers posed in front of an unidentified building in Morenci. (Silver print, photographer unknown, c. 1905. Collection of the author © vintagephoto.com.)

The Morenci Club was built to provide entertainment for the bustling community. The club building was next to the Morenci Southern Railroad across from the Hotel Morenci and the Phelps Dodge Company Store. Amenities included billiards, a bowling alley, a library, and a theater. (Detail of stereoview by A.H. Davidson, c. 1903. Collection of the author © vintagephoto.com.)

Even events as simple as the arrival of the train could draw a crowd. This event is identified as a Cinco de Mayo celebration and shows the range of men, women, and children that lived in the then-thriving town of Morenci, Arizona Territory. The Morenci Club is the building at the left rear, and the edge of the Hotel Morenci is visible in the center, with the Phelps Dodge Company Store along the right of the image. (Detail of stereoview by A.H. Davidson, c. 1905. Collection of the author © vintagephoto.com.)

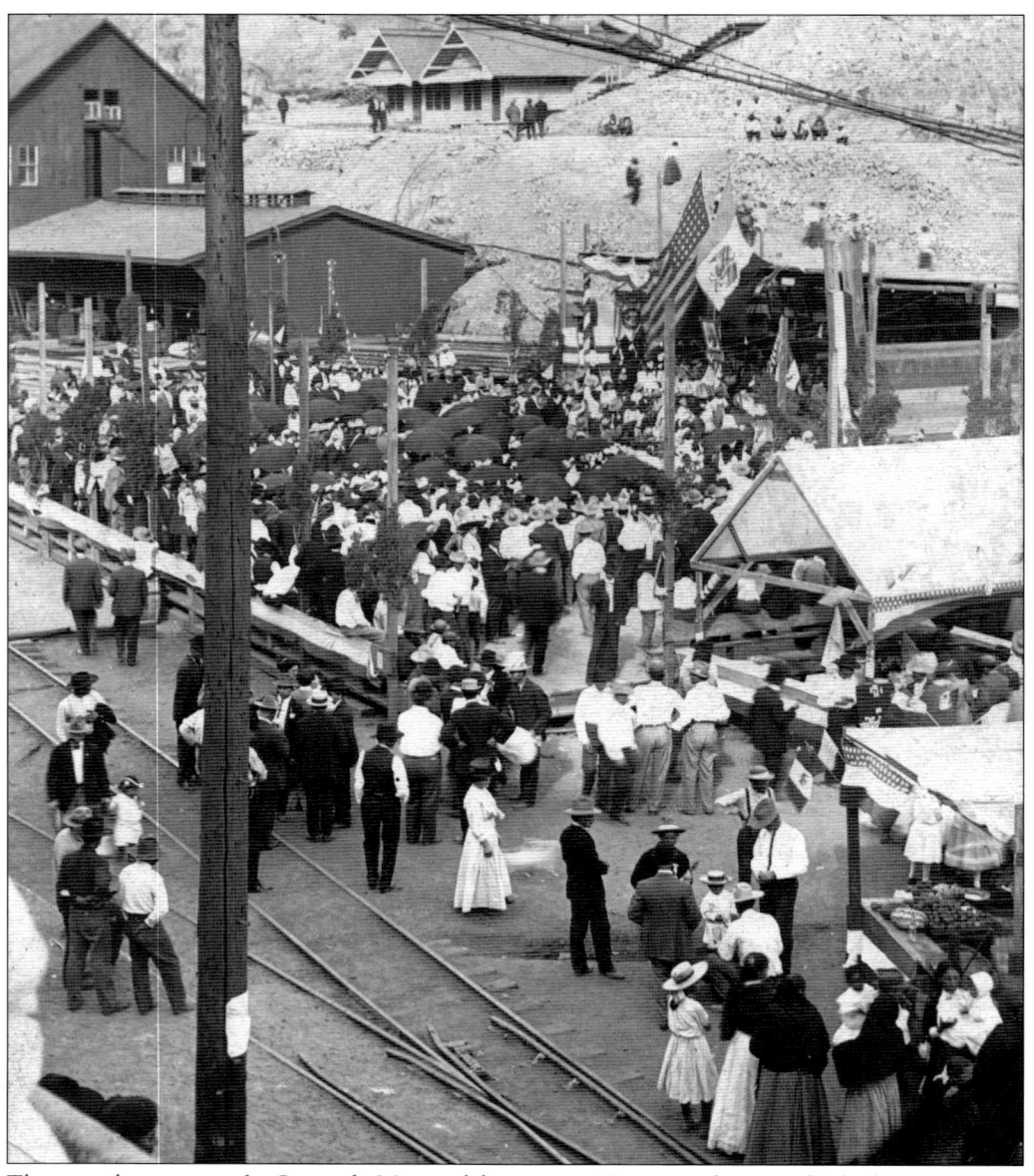

This is a closer view of a Cinco de Mayo celebration in Morenci. The town had a large Hispanic population with two separate "Mexican settlements." Note the Mexican flag on display and the huge crowd of miners and their families that turned out in their Sunday best. (Detail of stereoview by A.H. Davidson, c. 1905. Collection of the author © vintagephoto.com.)

This overview of Morenci from the top of the hill shows the way the town wrapped around the mining operations. The photographer manipulated this image while printing to try to create a dramatic twilight scene. (Silver print by Fisk, c. 1915. Collection of the author © vintagephoto.com.)

Morenci was located high enough that, unlike most of Arizona, it periodically received a dusting of snow. This image shows the snow-covered rooftops in the winter of 1906. (Detail of stereoview by A.H. Davidson, c. 1906. Collection of the author © vintagephoto.com.)

This January 24, 1903, construction scene shows the framework of the Shannon Copper Company smelter as it was being built on Clifton's Cemetery Hill to process ore from Metcalf. Note the men posed on top and bottom of the building to provide a sense of scale and the steam engine providing power for the construction crew at the lower right. (Silver print, photographer unknown, c. 1903. Collection of the author © vintagephoto.com.)

Mining camps and towns were often rough and rowdy. Clifton used a portion of a mine shaft blasted into solid rock as its original jail. (Silver print, photographer unknown, c. 1900. Collection of the author © vintagephoto.com.)

Like the mines, remote towns found obtaining power challenging. This unusual acetylene-powered generator was noted as being built in the basement of one of the offices or businesses of Clifton to produce electricity. (Real-photo postcard, photographer unknown, c. 1912. Collection of the author © vintagephoto.com.)

This view shows five individuals, two on horseback, posing by the railroad that led to the Arizona Copper Company smelter at Clifton. Note the busy smelter buildings in the rear and a dry goods store with a Coca-Cola sign on the right. (Real-photo postcard, photographer unknown, c. 1915. Collection of the author © vintagephoto.com.)

The Arizona Copper Company smelter grew to keep pace with the output of copper ore in the region. This scene shows several men at work in the smelter. (Real-photo postcard, photographer unknown, c. 1915. Collection of the author © vintagephoto.com.)

Like Bisbee, Globe, and several other mining communities, labor organizations in Clifton pushed back at the mine owners for better working conditions and pay. This image shows the group of about 500 striking miners in Clifton in September 1915. (Real-photo postcard, photographer unknown, c. 1915. Collection of the author © vintagephoto.com.)

Much of Clifton was built along the banks of the San Francisco River. When the river rose, the town flooded. This undated flood scene shows the rail beds adjacent to the river washed out by the raging water. (Real-photo postcard, photographer unknown, c. 1905–1910. Collection of the author © vintagephoto.com.)

Much of the entertainment in the remote mining communities initially focused on bars and saloons. As communities developed, they built more family-friendly spaces. This image shows the Princess Theatre, built extremely close to the railroad tracks that snaked through Clifton. One can only imagine the experience of trying to watch a movie as a heavily loaded train passed by only a few feet away. (Real-photo postcard, photographer unknown, c. 1915. Collection of the author © vintagephoto.com.)

WATCH JOHNSON!

JOHNSON is a copper camp in the Little Dragoons six miles from Dragoon Station. This camp is connected with the main line of the Southern Pacific by a standard gauge railroad.

JOHNSON CAMP is shipping ore at a rate of approximately $2,000,000 per annum.

THE JOHNSON COPPER DEVELOPMENT COMPANY'S property is in the heart of the camp, with producing mines on three sides of it.

This company is offering a block of treasury stock at 50 cents per share.

Let us tell you more about this property.

Address

Ralph R. Wilson, Frankfort, Ky.

or

J. T. Tong, Johnson, Arizona

This booster ad was run on May 14, 1916, by J.T. Tong in the *Bisbee Daily Review*. The ad promoted the camp and its productivity stock offerings for his company in Johnson, Arizona. (Collection of the author © vintagephoto.com.)

Eight

JOHNSON

Mining operations began on the east side of the Little Dragoon Mountains in Cochise County in southeastern Arizona about 1881, when the Peabody, Republic, and Mammoth claims led to the establishment of Russellville. The copper camp of Johnson initially grew slowly nearby, eventually justifying a post office in 1900. The little town quickly surpassed Russellville and grew to a population of 317 in 1902.

The Johnson Copper Development Company was capitalized at $300,000, and Col. William Cornell Greene purchased the Greene Consolidated Copper Company. Both mines were soon shipping a carload of high-grade ore to a smelter in El Paso by rail daily. The *Bisbee Daily Review* noted, "Johnson will take on a new life and undoubtedly add another producing camp to Arizona's list of big producers of copper."

In May 1909, the Black Prince struck a body of sulfide ore that yielded 25–35 percent copper at a depth of 430 feet. The Centurion found ore at a depth of 160 feet yielding 25 percent copper.

By 1910, the Peacock Copper Mining Company had erected a hoist and had two carloads of ore ready to ship. The Arizona United Mines Company built and ran its own 125-ton smelter, and it, the Centurion, and Black Prince were all regularly shipping ore.

The year 1916 saw the largest output of the mines at Johnson. The Cobriza Company was shipping four cars of ore a day. The Arizona Michigan shipped one or two cars a day to the smelter at Douglas, and the Peabody was shipping about three cars a week.

Active groups at Johnson included the Black Prince Mine, Peacock Mine, Arizona Copper Shipping Company, Arizona and Michigan Company, United Mines Company, Keystone Copper Company, St. George Mining Company, Cochise Development Company, Johnson Copper Development Company, Sims Mountain Copper Company, Centurion Company, and Empire Copper Company.

The Johnson District avoided the labor unrest that hit Bisbee, Clifton, and other mining communities in 1917. By 1918, production was still strong, with Arizona United Mines shipping four carloads of ore a day by rail to the smelter at El Paso.

Johnson had a population of about 1,000 in 1925, but the dropping price for copper led to cutbacks and emigration from Johnson to more successful mining communities. The post office at Johnson closed in 1929, and Johnson was well on the path to becoming a ghost town, with some copper, zinc, and silver mining resuming after World War II.

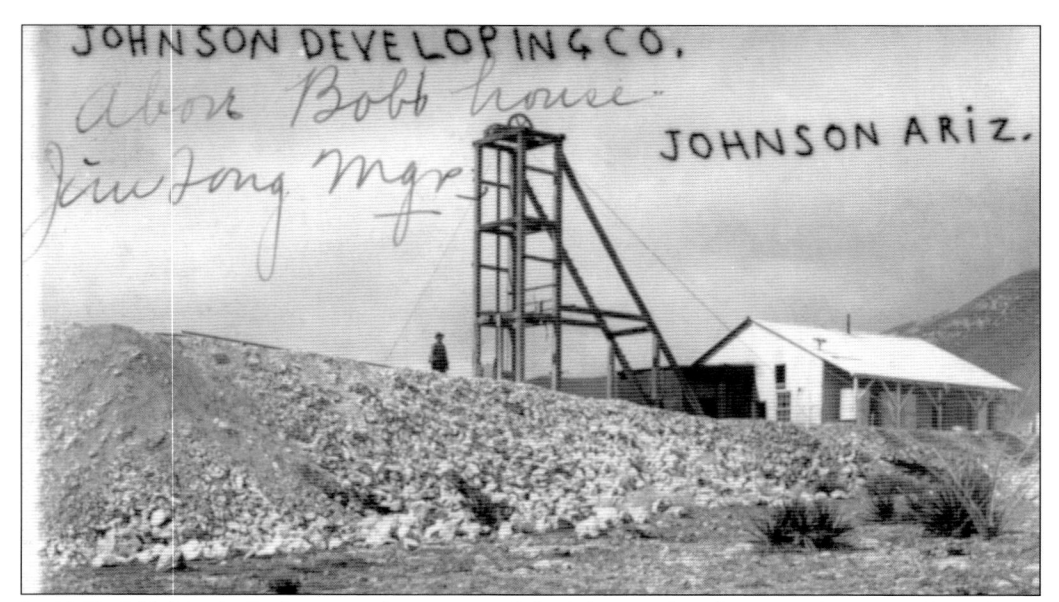

In 1909, F.H. Mitchell, the general manager of the Johnson Development Company, brought in new machinery to sink the shaft to 200 feet. This view shows the vertical headframe and hoist building that housed the 40-horsepower gasoline engine and air compressor to power air drills behind the tailings of the Johnson Developing Company mine. (Real-photo postcard by Dale T. Mallonee, c. 1917. Collection of the author © vintagephoto.com.)

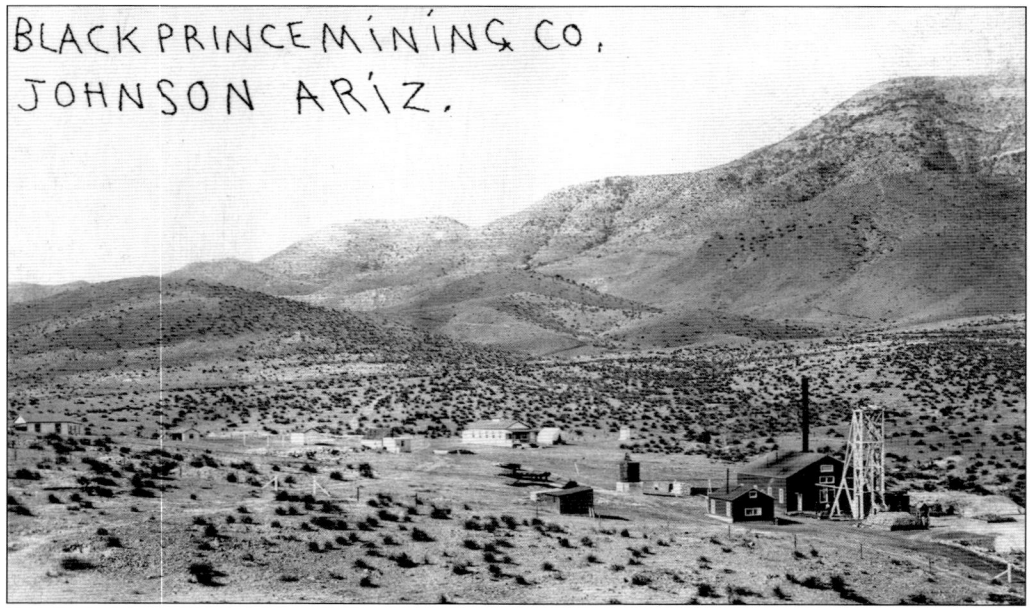

This overview shows the hoist, engine house, and operation at the Black Prince Mining Company in the foothills of the Dragoon Mountains about a mile north of Johnson. In 1909, the 160-foot-deep Centurion Shaft at the Black Prince struck a rich, six-foot-thick, 25–35 percent copper ore vein at 430 feet that produced 25 percent or better quality copper ore. But by 1915, only 10 men were working at the mine. (Real-photo postcard by Dale T. Mallonee, c. 1917. Collection of the author © vintagephoto.com.)

This image shows the operation at the Republic Mine, operated by the Cobriza Mining Company at Johnson. Note the large fresh slag heap of material removed from the mine in the foreground. (Silver print, photographer unknown, c. 1917. Collection of the author © vintagephoto.com.)

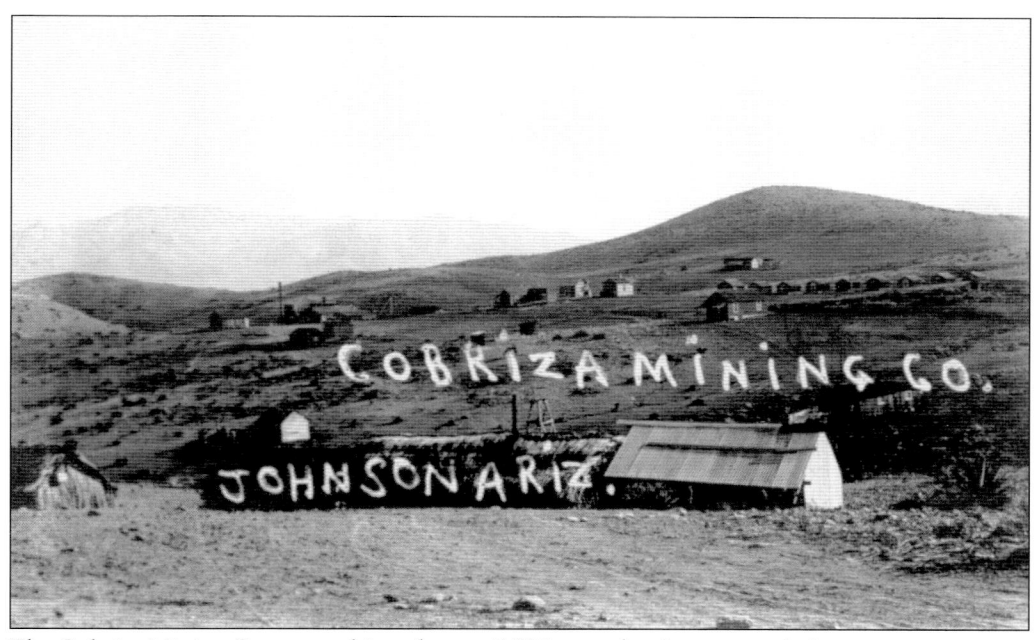

The Cobriza Mining Company shipped up to 5,500 pounds of ore a month from its operations at the Republic and Mammoth Mines. In 1916, the company grew its operation by purchasing the 60-acre smelting plant and silver and lead slag dump at Benson, Arizona. (Real-photo postcard by Dale T. Mallonee, c. 1917. Collection of the author © vintagephoto.com.)

The Arizona United Mines Company built a 125-ton smelting plant in 1909 to expand capacity as mining output grew. The smelter closed in 1916 when the Southern Pacific Railway attempted to raise shipping costs for ore from Johnson. After transportation rates were stabilized by the Corporation Commission, the smelter resumed operation. (Real-photo postcard by Dale T. Mallonee, c. 1917. Collection of the author © vintagephoto.com.)

In 1912, increasing prices for copper drove even more activity at Johnson. The town had grown to three miles long and was a mile wide from east to west on the eastern side of the Dragoon Mountains. This overview shows a mix of rapidly constructed temporary wooden and canvas residences that interspersed the more permanent wooden structures that made up the town of Johnson. (Real-photo postcard, photographer unknown, c. 1915. Collection of the author © vintagephoto.com.)

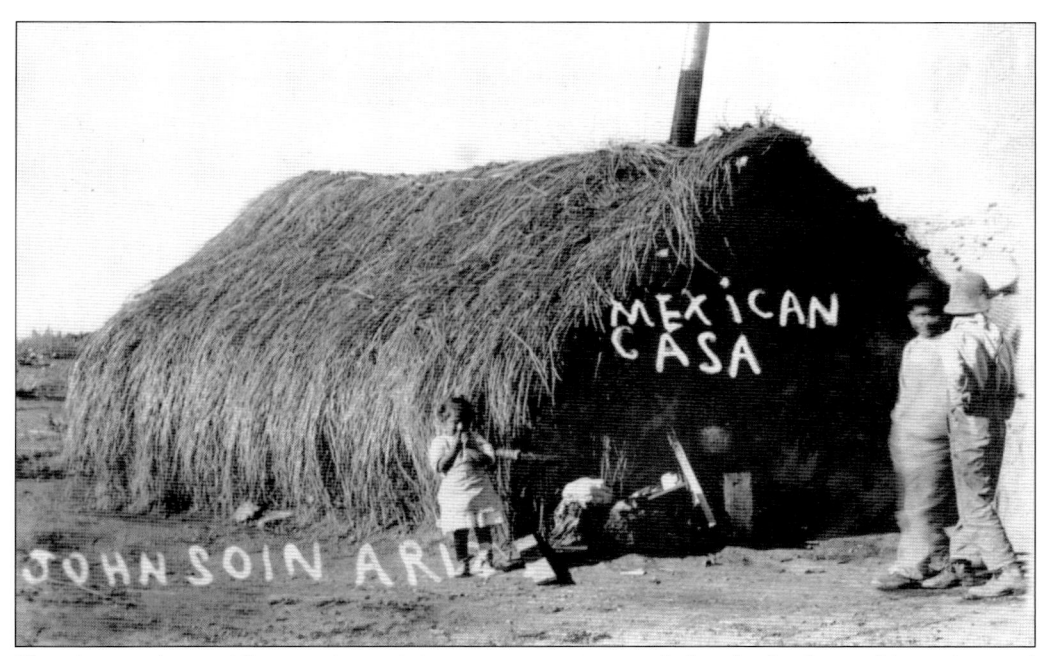

Housing in the rapidly growing mining communities needed to be built quickly and varied dramatically in scope and sophistication. This image shows a thatched hut that is a far cry from even canvas and pallet, let alone the more formal wooden structures. (Real-photo postcard by Dale T. Mallonee, c. 1917. Collection of the author © vintagephoto.com.)

As families joined the communities, amenities like schools and churches were built. This image shows the new one-room schoolhouse that was built at Johnson, led by female principal Mollie Brown. (Real-photo postcard by Dale T. Mallonee, c. 1917. Collection of the author © vintagephoto.com.)

This view is looking north at the Johnson townsite. Period manuscript identifications include J.T. Tong's home, Old Lady O'Hara's house, the Picture Store, and the lumberyard. Note the headframe of the Johnson Development Company behind the town on the left. (Real-photo postcard by Dale T. Mallonee, c. 1917. Collection of the author © vintagephoto.com.)

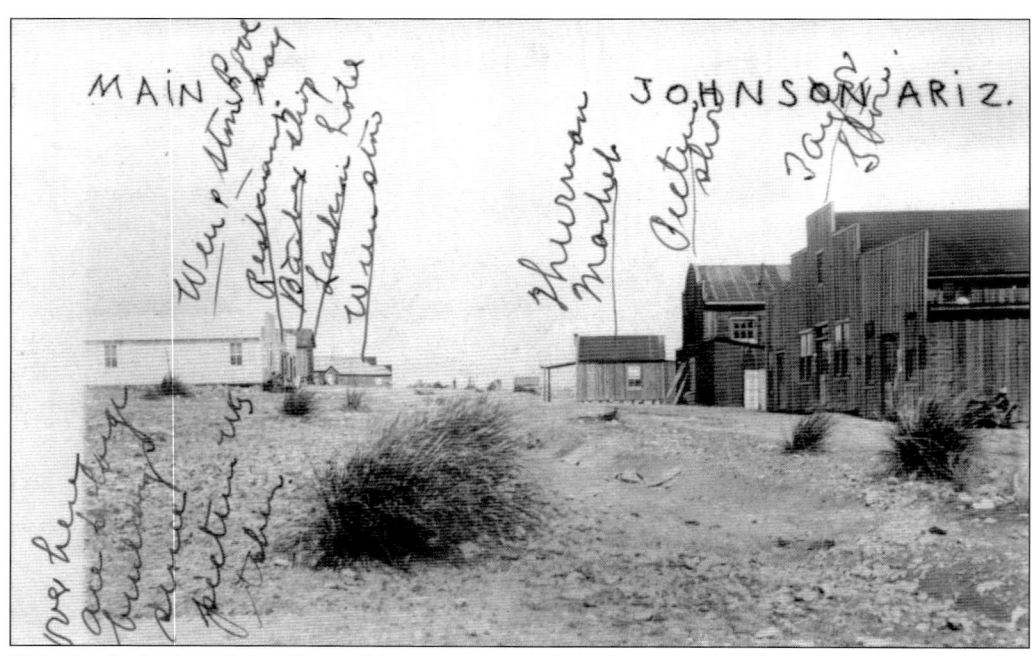

This view looks down Main Street, Johnson, Arizona, from the storage buildings. Manuscript locations noted include Wen & Stein pool hall (one of three in Johnson), a restaurant (Perry & Sons), a barbershop (A.L. Martin), T.B. Larkin's rooming house, A.H. Wein's general store, Albert Thurman's meat market, William Seliger's Picture Show, and B.A. Taylor and L.W. Rader's general store. (Real-photo postcard by Dale T. Mallonee, c. 1917. Collection of the author © vintagephoto.com.)

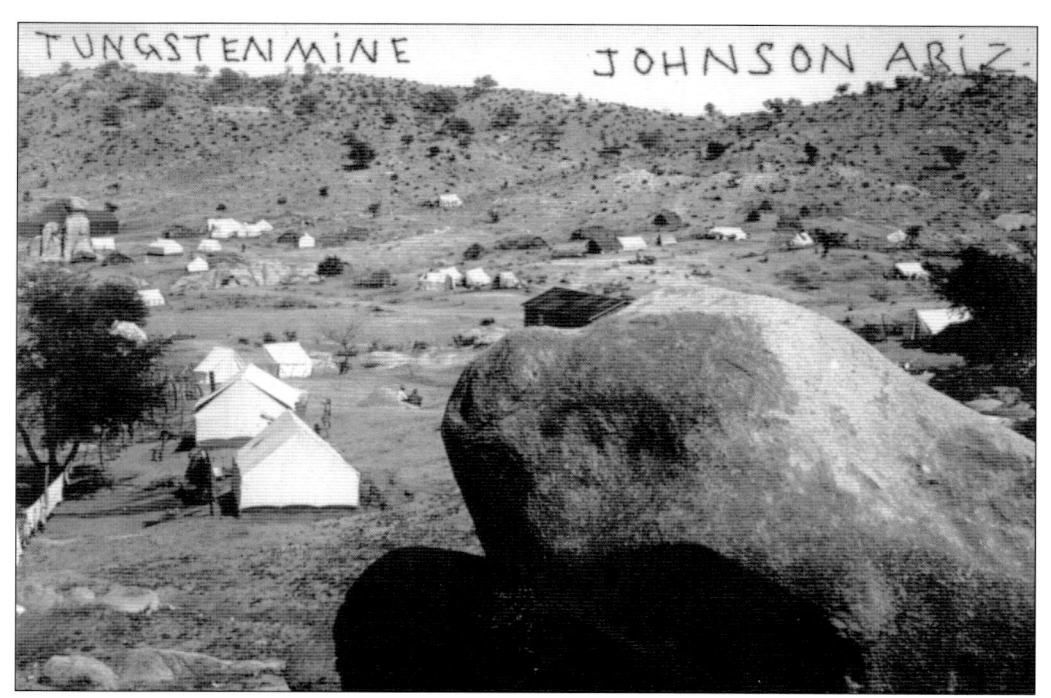

Johnson had some of the richest and purest deposits in the United States at the beginning of the tungsten boom. An assay of one deposit was valued at $19,000 per ton of ore. (Real-photo postcard by Dale T. Mallonee, c. 1917. Collection of the author © vintagephoto.com.)

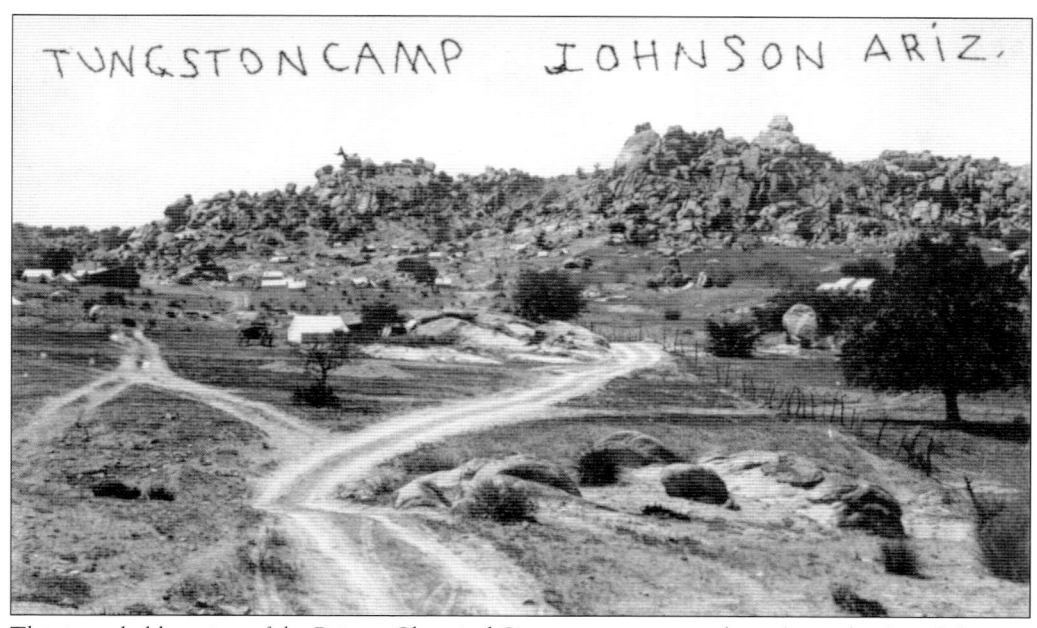

This is probably a view of the Primos Chemical Company operation about five miles from Johnson. The boom eventually led to surpluses of the precious metal and dropping prices. (Real-photo postcard by Dale T. Mallonee, c. 1917. Collection of the author © vintagephoto.com.)

Tombstone Consolidated Mines

The mines relied on the miners, equipment, and supplies that came from above ground. This view shows a group of men at the Tombstone Consolidated Mine loading the heavy metal cage of the skip car that was lowered from the massive new vertical steel headframe to haul men and equipment in and out of the mine. (Real-photo postcard, c. 1910. Collection of the author © vintagephoto.com.)

Nine

TOMBSTONE

One of the most legendary mining towns is Tombstone, purportedly named for the warning given to its founder Ed Schieffelin that all he would find prospecting in the Chiricahua Apache territory near Camp Huachuca would be his tombstone. The rich silver ore Ed found led to a partnership with his brother Al and Richard Gird, leading to the development of the mine and sparking a silver mining boom in 1877, which started the rapid growth of Tombstone on Goose Flats.

Tombstone has a rich, well-documented history, so this chapter will provide only a brief overview with some seldom-seen images that document the mines and town of Tombstone.

Only 25 miles from the Mexican border, Tombstone quickly became a potentially explosive mix of miners, ranchers and cattlemen, con men, investors, capitalists and entrepreneurs, and their families.

Like most mining communities, access to water for mine smelters and the community, let alone sufficient volume and pressure, made dealing with the ever-present threat of fires challenging. In its heyday, and despite fires that decimated the downtown business district on June 22, 1881, and May 16, 1882, the population of Tombstone was about 8,000 in 1882. Amenities in the town rivaled other major Western cities, with the Schieffelin Hall opera house, Bird Cage Theatre, a bowling alley, an ice-cream parlor, several watch and clock makers, three newspapers (the *Daily Epitaph*, *Daily & Weekly Nugget*, and *Tombstone Republican*), four churches, two banks, a school, fourteen gambling halls, many dance halls and brothels, and an estimated one hundred ten saloons. Visitors could stay in the Brown's, Cosmopolitan, or Grand Hotels or in Delmonico's or other lodging houses and choose sustenance from scores of restaurants and chophouses.

In the mid-1880s, the mine shafts penetrated the water table, and despite huge investments in pumps and related equipment, the mines continued to flood. After several years of fighting the rising water levels in the mines, in 1886, yet another fire destroyed the Grand Central hoist and pumping plant. The resulting gap in pumping led to sufficient flooding to close the mines.

The population of Tombstone dropped to about 1,800 by 1890 and then to about 600 in 1900. A short-lived resurgence of mining activity in 1902 briefly breathed a little life back into the town. Unlike many of its peers, after the mines closed, Tombstone was able to capitalize on its reputation and make a successful transition into a tourist destination.

Tombstone was founded in 1877, after Ed Schieffelin discovered silver while scouting on a mission against the Chiricahua Apache. The name allegedly came from comments made by soldiers that all Schieffelin would find when he first started exploring the area was his tombstone. This overview from the early 1880s looking north shows the growing town behind the mining works in the foreground. (Boudoir cabinet card by C.S. Fly, c. 1880s. Collection of the author © vintagephoto.com.)

This scene shows a group of miners at work at an unidentified mine near Tombstone (possibly the Tough Nut Mine). The tableau shows eight miners in various poses, including the group in the center adjacent to the mine shaft apparently demonstrating double jack drilling. (Cabinet card by Henry Buehman and Frank Hartwell, c. 1885. Collection of the author © vintagephoto.com.)

Charleston, Contention City, and Millville were sites of mills constructed to support the mines of Tombstone in the early 1880s. This view shows photographer Charles O. Farciot posed in front of his home in Charleston with the mill behind at the right side of the image. (Albumen print by Charles O. Farciot, c. 1880. Collection of the author © vintagephoto.com.)

Most of the images Charles Farciot captured of mining in Arizona were produced as stereographs. This image, titled "Office of the Tombstone Mine," was No. 109 in the series he produced between 1879 and 1883. (Detail of stereoview by Charles O. Farciot, c. 1880. Collection of the author © vintagephoto.com.)

Sports and social events provided an escape that helped miners cope with their hard lives. The Tombstone Nine baseball club was organized in 1882 and, for years after, traveled to mining camps throughout Arizona to compete with other teams. Matches during this era included challenges by Tucson, San Pedro, Nogales, and Albuquerque, New Mexico. (Albumen print by Camillus Fly, c. 1887. Collection of the author © vintagephoto.com.)

These two overviews taken from the water tower are part of a panoramic series of stereoviews of Tombstone that were produced by itinerant traveling photographer Olaf P. Larson. Tombstone Consolidated Mining Company purchased rights to major mines in the area in the early 20th century, including the Grand Central, Contention Consolidated, Head Center, Tranquility, and the Tombstone Mining and Milling Company, to restart a profitable mining operation. The overview above of Tombstone looks west from the water tower to show Tombstone at the start of its short second boom. The view below looks southwest over the remnants of the town in the early 20th century, as mining operations briefly restarted. Note the iconic Tombstone Courthouse in the center of the above image. (Details of stereoviews by Olaf P. Larson, c. 1905. Collection of the author © vintagephoto.com.)

This view shows the boardwalk sidewalk and unpaved streets of Tombstone as it struggled to recover as mining restarted in the early 20th century. Note the business sign of Chinese lawyer Lee O. Woo at the upper right. (Detail of stereoview by Olaf P. Larson, c. 1905. Collection of the author © vintagephoto.com.)

Titled "The Great Gallows-Frame at the Boom Mine," this view shows the massive new vertical steel headframe that was constructed at the pump shaft of the Boom Mine during the renewed mining investments by the Tombstone Consolidated Mining Company. (Detail of stereoview by Olaf P. Larson, c. 1905. Collection of the author © vintagephoto.com.)

Behind the massive slag heaps in the foreground are the Tombstone Consolidated Mining Company mill and the new vertical steel headframe of the Boom Mine. Note the artistic composition with the mine framed by the cactus in the foreground. (Detail of stereoview by Olaf P. Larson, c. 1905. Collection of the author © vintagephoto.com.)

The Tombstone Consolidated Mining Company was formed in 1900 to rebuild the mining industry in Tombstone by E.B. Gage and W.F. Stanton in an attempt to use pumping technology to remove the water that had flooded and led to the closure of the mines by 1890. This view shows an overview of the Grand Central Mine and tailings. (Real-photo postcard, c. 1910. Collection of the author © vintagephoto.com.)

This overview of the Tombstone Consolidated Mining operations carries the manuscript notation "Get into a rubber coat and hat, step into a cage, and then shoot down a thousand feet into the ground so quickly you don't know what has happened. I tell you it is a mighty queer sensation. Want to try it?" This view shows the Grand Central Mine buildings in front of the mill with its multiple stacks, some tailings that are being reprocessed, and the massive vertical steel headframe. (Cyanotype real-photo postcard, c. 1908. Collection of the author © vintagephoto.com.)

New cameras after 1900 made panoramic images easier to produce. This overview of the Tombstone Consolidated Mining operations shows the new vertical steel headframe at the Grand Central Mine that was used to carry men and equipment into the mine, with the multiple stacks of the mill visible to the right of the headframe and the slag heaps filling the foreground. (Real-photo postcard c. 1910. Collection of the author © vintagephoto.com.)

The Tombstone Consolidated Mining Company operated this 40-stamp Contention Mill. This image shows the cyanide leaching tanks and the spillway leading off to the right. (Real-photo postcard, c. 1911. Collection of the author © vintagephoto.com.)

The Arizona & Southern (A&S) Railroad engine No. 1 and three numbered A&S ore cars were used to haul ore and supplies around the grounds of the Tombstone Consolidated Mining Company. Note the old ore car and other mining detritus that litter the foreground. (Real-photo postcard, c. 1910. Collection of the author © vintagephoto.com.)

Water Discharge Con. Co.

This view shows the massive water flow from the mine's pumps into the discharge pond that was built adjacent to the mine. The pumping volume eventually reached five million gallons of water brought above ground each day to try to clear the underground shafts. Once again, a pump failure, this time attributed to poor fuel, let the water level rise beyond the capacity of the pumps, leading to the second demise of mining in Tombstone in 1911. (Real-photo postcard, c. 1910. Collection of the author © vintagephoto.com.)

This view (probably taken looking west) from the Tombstone Consolidated Mining Company operations looks across the water discharge pond that was built to contain the output of the pumps used to clear the underground mines. Note the town of Tombstone in the background at the right of the image. (Real-photo postcard, c. 1910. Collection of the author © vintagephoto.com.)

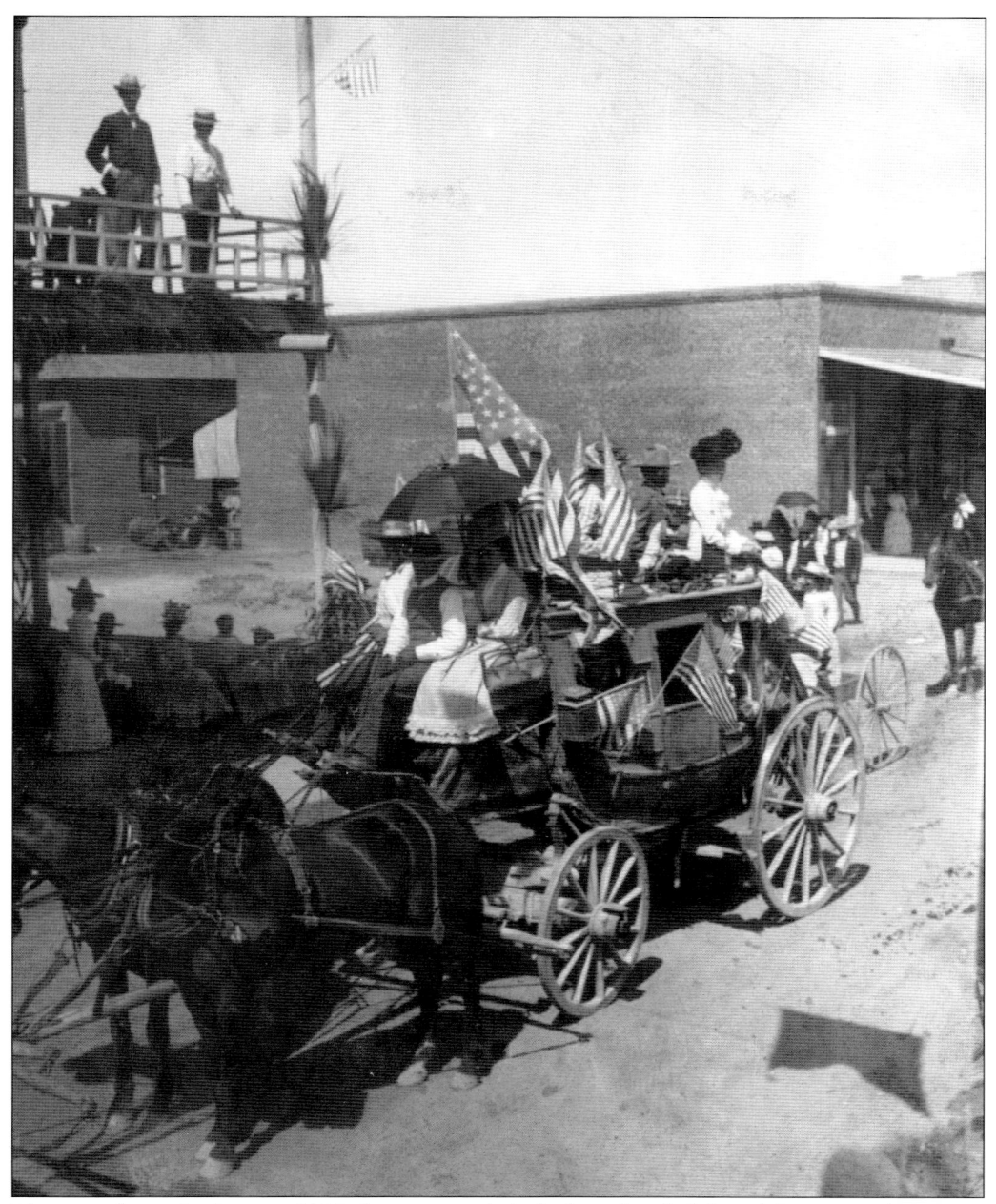

This view shows the famous old Modoc stagecoach decked out for a holiday celebration in downtown Tombstone. The Concord stagecoach was brought to Tombstone by Sandy Bob and began operating in the early 1880s and was retired about 1895. The coach was pressed back into service during the minor boom in 1902 for the run between Tombstone and Fairbank. It was finally retired once again in 1903 and then used only for special occasions, like this parade. (Detail of stereograph, photographer unknown, c. 1910. Collection of the author © vintagephoto.com.)

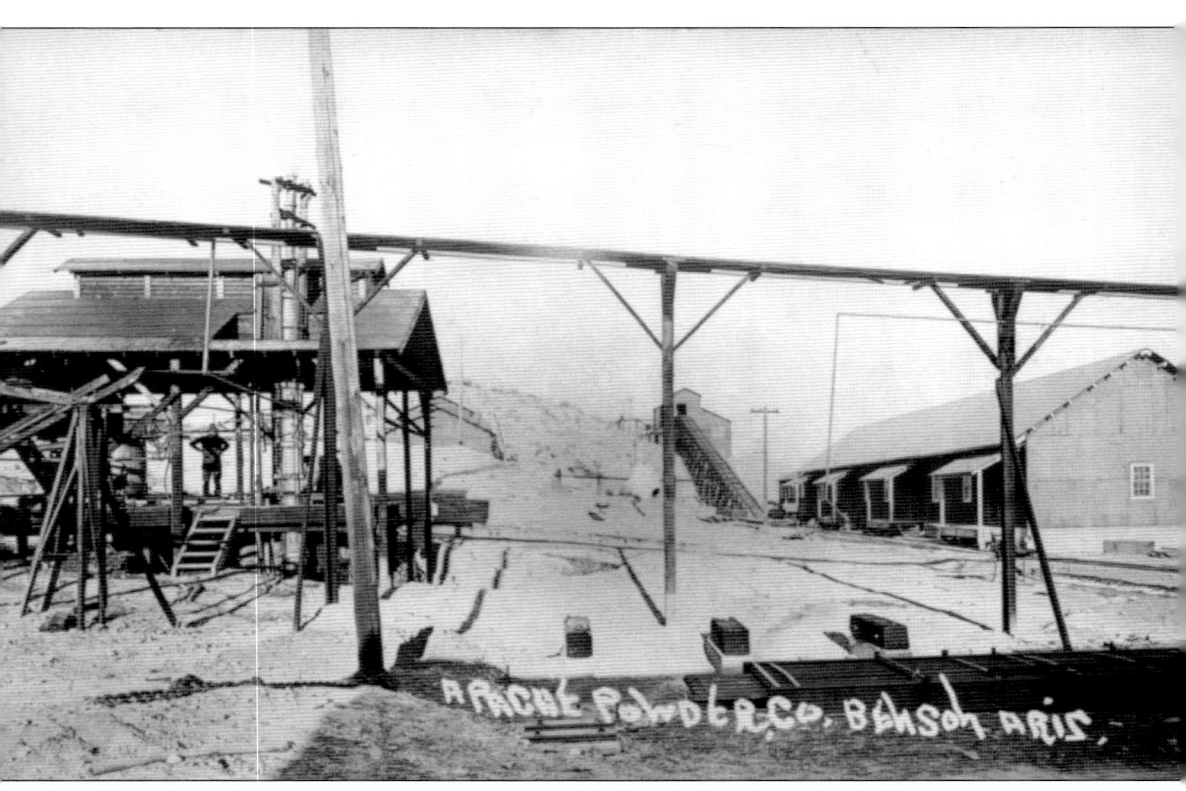

The Apache Powder Company was located at Curtis, the Southern Pacific Railroad stop outside St. David, near Benson in Cochise County. Incorporated in 1920, the company was a cooperative venture established to support the production of the explosives needed by mines in the Southwest. The location was selected for its proximity to active mines in the area, and the Southern Arizona climate was considered beneficial to the production of high-grade powder. The plant was completed in 1922 and produced over one million pounds of blasting powder a month by 1923. (Real-photo postcard, photographer unknown, c. 1923. Collection of the author © vintagephoto.com.)

Ten

OTHER SOUTHERN ARIZONA MINING OPERATIONS

Mining operations throughout Southern Arizona regularly opened as strikes were made and closed as ore quality dropped, veins petered out, or commodity prices for precious metals dropped. Some stayed small, while others grew into substantial operations with associated towns before slowly fading away. Some were redeveloped decades later as technology and demand for new minerals made them economically viable. But today, most of these operations are known only by the ruins that remain and a few historic photographs. This chapter includes a portfolio of images related to several mines that operated in the late 19th and early 20th centuries but today remain little known.

Included from Cochise County are images of the Apache Powder Works in Benson, operations at Pearce, and an unidentified operation in the Huachuca Mountains. Images of the operations at Silverbell come from Pima County. Pinal County will be represented by images of Belgravia, the Buckeye Mine & Milling Company, and Kelvin and related to Buffalo Bill and his Cody-Dyer Arizona Mining and Milling Co. A group of images from the King of Arizona (KofA) mines are an example of mining operations in Yuma County.

Located in the Mescal Mountains about a mile from Kelvin in Pinal County, Belgravia was named for a suburb in South Africa. The post office was established in the town associated with the mine on April 15, 1918. This view shows the temporary miners' housing in the foreground and the Arizona-Hercules Copper Company mill at right rear. (Real-photo postcard, photographer unknown, c. 1918. Collection of the author © vintagephoto.com.)

The Buckeye Mine & Milling Company operated in the mountains north of the town of Dos Cabezas, where mining operations began around 1880. This image shows a visitor to the old, abandoned site of the Buckeye State Mine & Milling Company of Tucson silver and zinc mine. (Silver print, photographer unknown, c. 1930. Collection of the author © vintagephoto.com.)

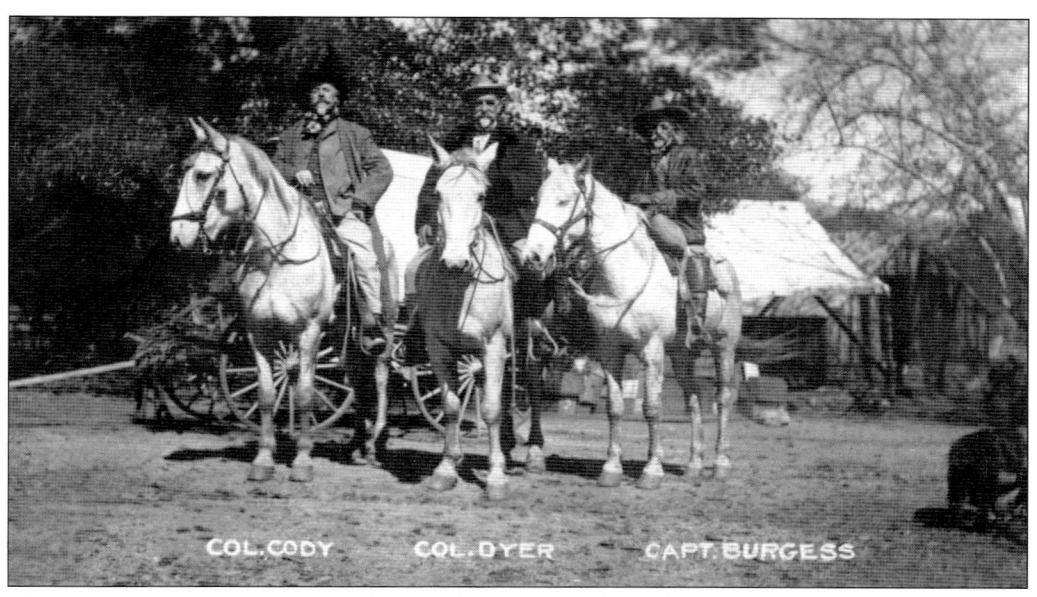

Far ms among the Terrace Garde

Famous Wild West show performer and owner Buffalo Bill Cody and his friend Col. Daniel Burns Dyer created the Cody-Dyer Arizona Mining and Milling Co. on March 13, 1903. In this image, Cody poses after his arrival in Yuma on October 18, 1908, for a visit to the mines he was investing in with Dyer and Capt. John D. Burgess near Oracle, Arizona Territory. (Real-photo postcard, photographer unknown, c. February 1910. Collection of the author © vintagephoto.com.)

COL. CODY COL. DYER CAPT. BURGESS

The Campo Bonito Mining and Milling Co. was formed to mine gold, silver, and tungsten near Oracle in 1910 with a $600,000 investment. Cody posed at one of his mines with Col. Daniel Burns Dyer and Capt. John D. Burgess. (Real-photo postcard, photographer unknown, c. February 1910. Collection of the author © vintagephoto.com.)

This view shows Buffalo Bill (at right) and his entourage in the field. Through his contacts, Cody was able to sell tungsten from his mines to Thomas Edison to manufacture light bulb filaments. Though Cody filed claims on the High Jinks, Campo Bonito, Maudina, Southern Belle, and Morning Star Mines, he failed to generate any return on his investments, which continually drained profits from his Wild West Show. (Silver print, photographer unknown, c. February 1910. Collection of the author © vintagephoto.com.)

The Kelvin-Sultana Mine was located in Pinal County in the Riverside Mining District near Point of Rocks. Kelvin was discovered by Jason K. McCarthy and C. Kinney. The underground workings consisted of a single shaft that produced copper ore from about 1903 to 1918. (Real-photo postcard, photographer unknown, c. 1910. Collection of the author © vintagephoto.com.)

This image shows the site of the mining blast that killed seven men working on the narrow-gauge Kelvin-Ray Railway on February 6, 1910. The railroad line ran on the north side of the Gila River across from the Riverside Stage Stop. After a series of successful detonations the day before, on February 6, a final charge was placed and lit. After the men thought the fuse had failed, they went to check the charge. As they approached, the explosion killed all seven men. The dead included the motorman on the train and one civil and five mining engineers working on the project. (Real-photo postcard, photographer unknown, c. February 1910. Collection of the author © vintagephoto.com.)

Portion Camp- King of Ariz (Kofa) Mine, Yuma Co. Arizona Carpenter Mill Wright (Anderson) L- BH CenTer; Dr - PO; K- STore - Assay Office.

Charles E. Eichelberger discovered gold ore in the Kofa Mountains 22 miles from Quartzite in Yuma County, Arizona Territory, in 1896. This image shows the carpentry shop at the King of Arizona mine. The building above is the assay office, store, and post office. L.W. Alexander was appointed the first postmaster for the new post office in July 1900. In 1919, a new company, the KofA Queen Mine and Milling Company, formed to continue the development of a 150-foot-wide vein of ore between the New King of Arizona and Lone Star Mines, which had been operating in the region. (Boudoir cabinet card, photographer unknown, c. 1905. Collection of the author © vintagephoto.com.)

The town was tucked in the foothills near the King of Arizona Mine. The Kofa Post Office was established on June 5, 1900. The town eventually grew to a population of 300, with a school, boardinghouse, and of course, several saloons. (Detail from a stereoview, photographer unknown, c. 1915. Collection of the author © vintagephoto.com.)

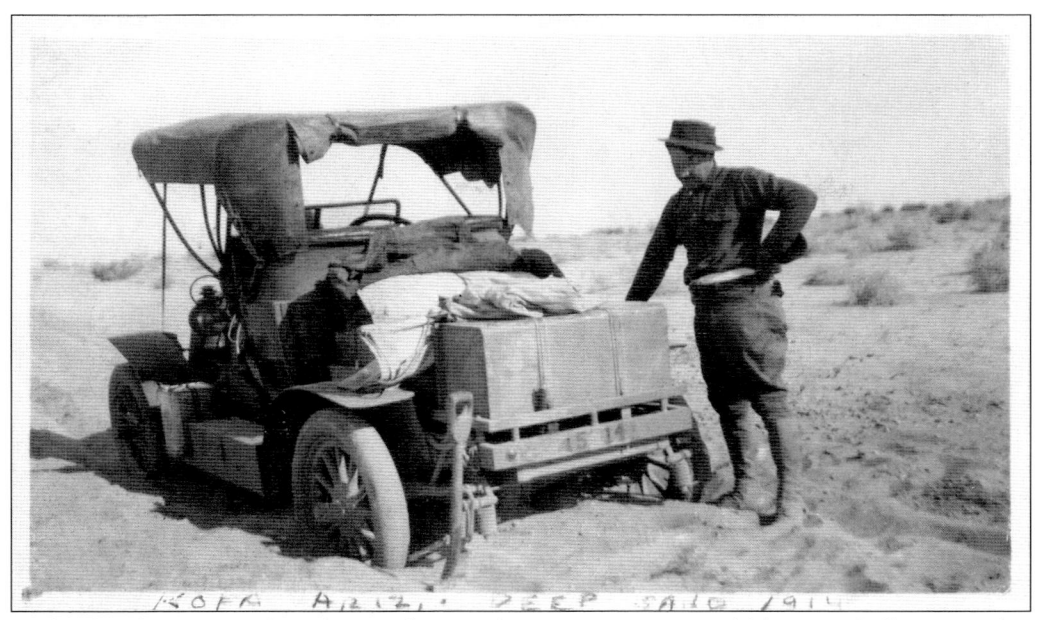

In the days before paved roads, travel in southwestern Arizona could be very challenging. This driver is mired in the sands en route to the remains of the KofA Mine and town of Kofa. (Silver print, photographer unknown, c. 1914. Collection of the author © vintagephoto.com.)

This image shows the same vehicle on a more successful trip about a year later, when it carried a family to the remains of Kofa in October 1915. Note the camera case hanging from the edge of the seat on the driver's side. (Detail from a stereoview, photographer unknown, c. 1915. Collection of the author © vintagephoto.com.)

Though initially producing an average of 200 tons a day averaging $40 per ton, the ore quality soon dropped dramatically. By 1910, after producing about $3.5 million in gold and silver bullion, mining operations at KofA began to close. This view shows what remained of the headframe, tailings, and empty cyanide tanks around 1915. (Detail from a stereoview, photographer unknown, c. 1915. Collection of the author © vintagephoto.com.)

Cornish miner James Pearce discovered gold between the Chiricahua and Dragoon Mountains and staked a claim for what would become the Commonwealth (or Common-Wealth) mine in 1894. This is a view looking south to the mill and smelter of the Commonwealth Mine from the town of Pearce, Arizona Territory. (Boudoir cabinet card, photographer unknown, c. 1900. Collection of the author © vintagephoto.com.)

This image shows the extensive mill and smelter at the mining operations of the Common-Wealth Mine at Pearce, Arizona Territory. It is labeled "looking east and group of Mexicans grading ore out of the hill" and shows the massive mill that had been built at Pearce in the background. (Boudoir cabinet card, photographer unknown, c. 1900. Collection of the author © vintagephoto.com.)

Pearce & Mill looking North shows Dragoon Mts in the west

This is an overview of the town of Pearce in its heyday. This image was captured looking north from the Commonwealth Mine in the Dragoon Mountains with the Pearce mill and smelter in the foreground. (Boudoir cabinet card, photographer unknown, c. 1900. Collection of the author © vintagephoto.com.)

The namesake town of Pearce grew near the mines in the Sulfur Spring Valley. The post office at Pearce was established in 1896, and a railway connection to Wilcox was completed in 1903. In 1915, Joe Bignon converted his saloon into a movie theater for the 1,500 residents. The boom ended, and by the Depression in the 1930s, the railroad tracks had been removed and Pearce was well on its way to becoming a ghost town. (Boudoir cabinet card, photographer unknown, c. 1900. Collection of the author © vintagephoto.com.)

This c. 1890s cabinet card by Fort Huachuca–based photographer Otto Schroeder shows a group of miners posed with heavily loaded pack mules in front of their primitive wood and canvas living quarters at an unidentified mine in the Huachuca Mountains. Many of the mines in the area were established by the soldiers and scouts that worked out of Fort Huachuca in the 1870s and 1880s. (Cabinet card, by Otto Schroeter, c. 1900. Collection of the author © vintagephoto.com.)

Mining began in the Silver Bell Mountains in Pima County in the 1860s. In 1874, Charles Brown from Tucson found the Mammoth Load, established the Young America Mine, and built a smelter at the site. Other mines in the region included the Atlas and Old Boot and, in the 1890s, the Silver Bell Mining and Smelting Company and Tucson Mining and Smelting Company. This view shows the vertical and incline hoisting works at the Mammoth Mine at Silverbell. (Albertype, c. 1909. Collection of the author © vintagephoto.com.)

Imperial Hotel,
Silverbell, Arizona.

Cinco de Mayo
MENU

| RIPE OLIVES | HEAD LETTUCE | YOUNG RADISHES |

MENUDO

PIPIAN DE GALLINA
CHILI CON CARNE
ENCHILADAS
TORTILLAS

Frozen Egg Nogg

| MASHED POTATOES | STEAMED POTATOES |
| LENTEJAS | FRIJOLES CON QUESO |

Fruit Salad

| FRESH APPLE PIE | BLUEBERRY PIE |

FROZEN CAFE NOIR WITH HOME MADE LAYER CAKE

| TEMPE CREAM CHEESE | SWISS CHEESE |

BENT'S WATER CRACKERS

| NUTS AND RAISINS | ASSORTED FRUIT |
| CUVIERTOS DE VISNAGA | MEXICAN CIGARETTS |

THURSDAY, MAY 5, 1910.

B. J. HALL, MANAGER.

This menu showing the extensive offerings available at the Imperial Hotel is an example of the rich social life that grew in the town of Silverbell. The annual Cinco de Mayo celebration commemorates the anniversary of Mexico's victory over the Second French Empire at the Battle of Puebla in 1862. (Collection of the author © vintagephoto.com.)

This c. 1909 view shows the town of Silverbell with the Union Mine in the background. Despite challenges with potable water, the towns of Silverbell and nearby Sasco grew rapidly. By 1910, Silverbell had a full complement of businesses and services ranging from groceries, teamsters, restaurants, and a photographer to boardinghouses, hotels, and a movie theater. Deteriorating output from the Imperial Mine led to a decline in population and local businesses and the closing of the Silverbell Post Office. After World War I, Silverbell saw a short-lived resurgence with the population briefly reaching 1,200 before a decade-long decline as copper processing fell in the 1920s. (Albertype, c. 1909. Collection of the author © vintagephoto.com.)

Background on the Photographs

One of the best links to Arizona's past is the photographs made by professional photographers and talented amateurs that documented the birth and development of Arizona. The format of the original image provides important information that can help identify and better understand the photographs. Where it is possible, the photographer that made the original image has been identified to provide additional information about the image and how it fits into the body of their work.

Though many of the images in this book were originally produced for sale, only relatively small numbers of each image were made. Others were produced by amateurs and may be the only copies. Unfortunately, over the years, many of these ephemeral historic photographs have been lost, damaged, or destroyed. As a result, the visual history that we see is largely based on serendipity. It is told only by the images that have survived, been collected, made available, and ultimately been correctly identified by collectors, researchers, museums, and archives. As a result, this history subtly changes over time as new images, and new information and scholarship about the images, become available.

To help better understand the context of the images, the credits for the photographs that appear in this book, when possible, include the format, photographer if known, and the approximate date they were created.

Every effort has been made to provide accurate caption information, based on the provenance of the image, format, content, and any other sources. The caption format requires abbreviated descriptions that hopefully provide sufficient information to help identify and allow the reader to enjoy and explore the images.

Photographic Format Information

Name	Approximate Image Size	Dates of Popularity
Boudoir cabinet card	5.5 x 8.5	1880s
Cabinet card	6.5 x 4.5	1866–1900s
Carte-de-visite	2.5 x 4	1850s–1900s
Stereograph	3.5 x 7 to 5 x 7	1850s–1950s
Real-photo postcard	3.5 x 5.5	1900 to present

The photographs in this book come from the collection of the author. The vintagephoto.com site provides additional information and other historic photographs.

DISCOVER THOUSANDS OF LOCAL HISTORY BOOKS
FEATURING MILLIONS OF VINTAGE IMAGES

Arcadia Publishing, the leading local history publisher in the United States, is committed to making history accessible and meaningful through publishing books that celebrate and preserve the heritage of America's people and places.

Find more books like this at
www.arcadiapublishing.com

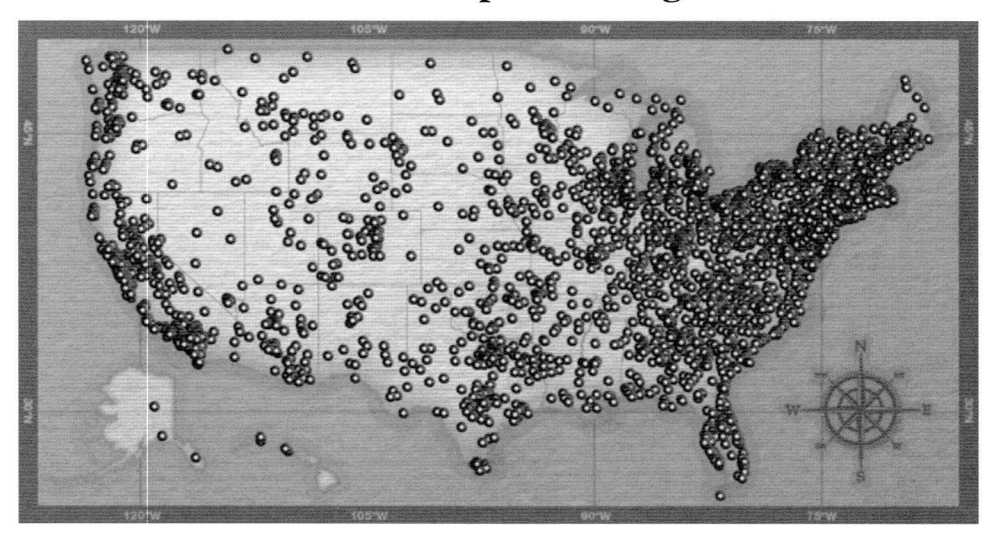

Search for your hometown history, your old stomping grounds, and even your favorite sports team.